do I have to wear white?

ALSO FROM THE EMILY POST INSTITUTE

do I have to wear white?

· · · · · · · · · · · · · · · ·

Emily Post Answers
America's Top Wedding Questions

Anna Post

COLLINS LIVING

An Imprint of HarperCollinsPublishers

Emily Post is a registered trademark of The Emily Post Institute, Inc.

DO I HAVE TO WEAR WHITE? Copyright © 2009 by The Emily Post Institute, Inc. All rights reserved. Printed in the United States of America. No part of this book may be used or reproduced in any manner whatsoever without written permission except in the case of brief quotations embodied in critical articles and reviews. For information, address HarperCollins Publishers, 10 East 53rd Street, New York, NY 10022.

HarperCollins books may be purchased for educational, business, or sales promotional use. For information, please write: Special Markets Department, HarperCollins Publishers, 10 East 53rd Street, New York, NY 10022.

FIRST EDITION

Designed by Jaime Putorti

Library of Congress Cataloging-in-Publication Data has been applied for.

ISBN 978-0-06-156387-4

09 10 11 12 13 OV/RRD 10 9 8 7 6 5 4 3 2 1

For my mom, who always has all the answers

contents

CONTENTS

acknowledgments

i first want to extend a special thank you to Tricia Post, whose terrific organization, dedication, and endless knowledge about the finer points of wedding etiquette have been essential in writing this book.

I'd also like to thank the following people who were so generous with their time and advice: my grandmother, Elizabeth Post, who wrote the original of this book; Peggy Post and Elizabeth Howell of The Emily Post Institute for their in-depth knowledge of everything wedding; Krista Washburn, editor-in-chief of *Vermont Vows* magazine, for her support and belief in the Emily Post message; and Debby Jarecki and Jen Jarecki of Scribbles, Vermont, for a tour of the world of wedding invitations and stationery. I'd like to give special thanks to Anna Hart and Cherlynn Conetsco for their invaluable help with questions involving military etiquette.

And finally, thanks go both to the thousands of people who have written to The Emily Post Institute with their wedding questions, and to "Emily's Army"—Lynn Ferrari, Nancy Dunn, Sarah Mulvehill, Danielle Ulrich, and Laura Bacon— the wonderful team who answers them so well.

introduction

*W*henever I hear a bride begin a wedding etiquette question with the words, "Am I supposed to . . . ", I know I almost always have two questions to answer, not one. There's her actual question, and then there's the question of tradition that is at the heart of a "supposed to" question. Traditions are wonderful when they hold meaning and value for you. They are *not* there to force your hand to do something that makes no sense for your situation, goes against your vision of your wedding day, or worse, is upsetting to you.

There are, however, good reasons for many of the traditions that are around, and my goal in this book is to show you why certain points of etiquette are important, even when they may feel burdensome. I'll show you the distinction between traditions that aren't set in stone, and points of etiquette that are truly inviolable, such as always inviting a guest's spouse, no

matter how much you may not like them. These traditions aren't there to frustrate you; instead they often have a purpose behind them that speaks to the heart of what etiquette is all about: treating others with consideration, honesty, and respect.

The question of whether a bride "has" to wear white is a perfect example of a "supposed to" question. Technically, no, she doesn't. Before Queen Victoria, brides simply wore their best dress, no matter the color. She set a trend that became tradition, and a beautiful one at that. But there's no rule of etiquette saying a bride *must* wear white. There is some etiquette for her to keep in mind, however, as she considers the question. Traditions carry a lot of weight, and breaking with them can draw people's focus away from the purpose of the day—a wedding and marriage—and fix it firmly on a detail, in this case a dress. It could be upsetting to others, especially those in older generations such as a mother or grandmother. The potential upset to them may not be worth the thrill of a colorful dress. None of this means that choosing a colorful dress is wrong or hurtful in and of itself; I simply suggest that you consider the situation in its entirety before breaking with traditions— whether it's the color of the bride's dress, serving ice cream sundaes instead of cake, or having a male maid of honor.

Anna Post, June 2008

congratulations ~ you're engaged!

✻ How do we tell our parents we're engaged?

It's traditional to tell the bride's parents first. You may each tell your parents separately, or you can go together. Whether the groom formally asks the bride's father for her hand or not, it's a sign of respect for the groom or the couple to discuss their plans with the bride's parents. If your parents don't know your fiancé, it's your responsibility to arrange the meeting. If families live far away, the news may be shared by phone and a visit planned as soon as possible, because there is nothing better than getting together in person.

✻ What if our parents are divorced?

This is a time to be sensitive and sensible, and set the tone for how you'll handle divorced or separated parents throughout the engagement and wedding. The news should be conveyed to each parent in person, if possible, and by the most direct and convenient means. There's no rule, but most people choose to tell the parent they are closest to first. Even if you're estranged from one parent, he or she shouldn't hear your news from outsiders.

✻ Is it still the rule that you don't say "congratulations" to the bride?

No, it's fine to congratulate the bride and the groom. Years ago, the standard was to offer the bride your "best wishes" for her happiness. It was considered in poor taste to say congratulations to a bride, as it conveyed a sense of "you finally got one!" Today, "congratulations" is the usual way to respond to the happy news.

✻ My boyfriend and I have decided to marry. He has a daughter from a previous marriage. Should we tell her or our parents first?

Since your fiancé has a daughter, she should be the first to hear the news, even before you tell your parents. Your fiancé should tell his daughter alone, without you, her future stepmom,

present. In fact, children of any age should be told about the engagement by the remarrying parent. They may need time to adjust to the idea. It's also a good idea for your fiancé to tell his ex-spouse right away, so that she can help smooth the way for their daughter's adjustment and involvement.

✳ Should I tell my ex that I'm engaged?

If your ex is a former spouse, and you share children, then yes, you should definitely tell him. Because of the inevitable changes taking place at home, your children will need both their parents for extra support. If you don't share children, your decision to tell him or not would depend upon how amicable the two of you have remained. If you are on friendly terms, then it's courteous to let him know.

If your ex is a former love, you have a few other issues to consider. First and foremost, be absolutely certain that your fiancé is aware and in support of your contact with your ex. It's important to respect his feelings on the matter. If the two of you keep in touch and share news occasionally, then sure, it makes sense that you would let him know your happy news.

✳ **Now that we're engaged, may I call my fiancée's parents by their first names instead of Mr. and Mrs. Singh?**

It's better not to make that leap unless invited. Continue to address them as Mr. and Mrs. until they suggest otherwise. Most married couples refer to their in-laws by their first names. After you're married, if they still haven't suggested a less formal address, then it's fine to ask them what they'd like you to call them.

✳ **My fiancé's parents want me to call them Mom and Dad. I'm not really comfortable with that, but I don't want to offend them either. What should I do?**

This definitely calls for some tact and sensitivity. First, have a chat with your fiancé and see if he has any insight regarding his parents' request. Then, have a little conversation with one or both of them and explain: "Mrs. Jones, I'm so honored that you would like me to call you 'Mom' and I appreciate this special way of welcoming me to your family. However, I'm uncomfortable calling anyone other than my mom, 'Mom.' Would it be all right if I called you 'Marge'?"

✳ **When do we tell other people that we're engaged?**

Once parents and children have been told the news, then share your engagement plans with other relatives and friends:

in person, by phone, by writing notes, or by sending e-mails. Just remember to be sensitive in the timing: You don't want your grandmother hearing the news secondhand from her hairdresser. Include grandparents, siblings, favorite aunts and uncles, godparents, and close friends as special people "in the know" before the rest of the world finds out.

❋ **My partner and I wish to have a commitment ceremony. Is there any etiquette involved in telling others of our decision?**

Ceremonies celebrating the partnerships of gay and lesbian couples are planned in much the same way as heterosexual weddings. The current lack of legal status in many states affects some aspects of the engagement and ceremony: There is no marriage license, mandated health testing, or a marriage certificate signed by a licensed officiant and witnesses. But this in no way limits the joy of the couple or of friends and family who share their happiness.

There isn't any set formula for sharing the news—each situation is personal—so let your knowledge of the people involved guide you. Reactions may range from delight to outright rejection. Even friends and families who approve of the relationship may express concern about the public nature of a ceremony. Be patient and give those who have a negative reaction time to digest the news.

As with any engagement, a partner's children should be told before the couple's parents. Still, some gay and lesbian couples prefer to tell their supportive friends even before parents or children. Receiving their positive, joyful reaction can be a morale booster prior to potentially difficult family discussions.

Not all negative reactions are based on prejudice. As with concerns regarding a heterosexual engagement, your friend or relative may have the traditional doubts about your choice of partner and future together: Is he right for you? Will you be financially stable? Do you have to move far away? Take the time to listen carefully.

✳ **We've just become engaged. My mom is waiting for my fiancé's mom to call and his mom is waiting for mine to call. Who makes the first move?**

Traditionally, once the couple has told their respective parents of their engagement, the groom's mother calls the bride's family to express happiness about the engagement and arrange to get together. Nowadays, it really doesn't matter who makes the call, but it's a good idea for the parents of the bride to wait a few days to give the groom's family the opportunity to honor the tradition. But if they don't, then the bride's mother should go ahead and call. The important thing is that contact

be made. Bottom line: Parents should act with spontaneity and in the spirit of friendship, whoever gets in touch first.

✳ My fiancé's parents are divorced. Who should set up the meeting with my parents?

When the groom's parents are divorced, the parent with whom he is closest should take the first step toward meeting the bride's parents. If both sets of parents are divorced, then the groom's parent most inclined to make the arrangements should contact whichever parent the bride suggests. If the groom's side doesn't initiate contact, then the bride's parents (or parent) should take the initiative and contact whichever parent the groom suggests. If no one is taking the initiative, then the bride and groom make sure that the parents meet in the most amicable way possible.

SMOOTHING THE WAY: *It's certainly best if the bride and groom do not force divorced parents into social situations that have the potential to make them and others uncomfortable. As much as the couple may want their parents to appear as an intact family in honor of the wedding, it's usually an unrealistic expectation.*

❋ What should we do if either of our parents or our children disapprove of the wedding?

When parents or children disapprove, it's natural to feel hurt, sadness, or disappointment. Many parents have some initial anxiety because they worry whether their child is making the right decision. That anxiety usually disappears once wedding plans are underway and they get to know their son or daughter's fiancé(e). But if the tension increases or a parent clearly voices objections, then the problem must be addressed openly.

- Stay calm and approach the discussion as adult-to-adult.

- Be willing to listen to parental concerns and to take them seriously. Address those concerns as best you can.

- Try to remember how important your happiness is to them and don't let minor disagreements get out of hand.

If you can't overcome their objections and still decide to marry, don't sever family ties. Make sure that they know when and where the wedding will be and how much it would mean to you to have them there.

When children disapprove, especially adult children, the dilemma is greater and family relationships can become quite strained. If time and communication can't bridge the gap, or basic civility and politeness have been abandoned, then professional counseling could be initiated to help the entire family understand one another's feelings.

✽ May we announce our engagement before I receive an engagement ring?

Yes. A ring is the traditional sign of a pledge of marriage, but it's not necessary to have a ring in order to be engaged. Some couples forgo the traditional engagement ring and use the funds to start their new life together. Others wait years until they can afford the special ring they envision.

✽ Does an engagement ring have to be a diamond? I'd love to have a ring that features our birthstones.

No, it doesn't have to be a diamond. Diamonds are the traditional choice, but the ring may have other precious or semiprecious stones, or even no stone. Some couples select gemstones that have special meaning, such as birthstones, as you suggest. If you're choosing a diamond, be sure to learn about the four *C*s: carat, cut, clarity, and color, as well as insisting on the fifth *C*: certification.

❋ Should my fiancé choose the ring himself or may we select it together?

Many couples choose the ring together and choose their wedding bands at the same time. In fact, only 30 percent of men choose an engagement ring alone. Most prefer to have help knowing what will make their fiancée happy. Remember to communicate tactfully: Ladies, don't insist on a ring that is outside your fiancé's budget, but gentlemen, do your best to accommodate your fiancée's taste.

❋ Do I have to wear the family heirloom?

The best of intentions can lead to misunderstanding and hurt feelings. While a groom's parents may be focused on honoring a family tradition by passing along an engagement ring, they may put the bride-to-be in an awkward position if she has her heart set on having her own ring. If she refuses, she may seem ungrateful; if she accepts, she may feel resentful. It's best if parents make the offer to their son before the rings are chosen. They should also let him know that they understand completely if the couple chooses a different ring or creates a new setting.

If you feel uncomfortable accepting the family heirloom, then you needn't do it. Decline graciously and be sure to dis-

cuss your concerns with your fiancé. A family doesn't have the right to insist that this very personal piece of jewelry be worn by their future daughter-in-law, no matter how strong the tradition.

✳ How long should an engagement be?

There is no "right" length of time for an engagement. In the past, the typical engagement period was a year or less. Nowadays, one to two years isn't unusual, especially if a couple wants to reserve a popular wedding venue or if school or career commitments need to be met first.

✳ Who gives an engagement party and when is it held?

Traditionally, the bride's family hosts an engagement party after the parents have a chance to meet, and soon after the engagement is announced publicly. Today, it's fine for another relative or close friend to host a party, but only after checking with the bride's parents. If the parents live in separate parts of the country, each family may wish to host a party for the couple in their hometowns. Just be sure to coordinate dates with the couple and give the bride's family first pick.

✻ **My fiancé and I have lived in Atlanta since college. Our parents live in Oregon and Maine. Is it okay to host our own engagement party?**

Sure! It's a great way to celebrate with the people who are important to you in the new life you've created since college. Be sure to invite your parents—they'll appreciate being included in this special event.

✻ **What kind of party should it be?**

There's no set format, but the most usual is a cocktail or dinner party. Whatever suits the couple and the hosts is just fine, so it could even be a surprise party, brunch, or a formal reception. Often the engagement party sets the tone for the wedding to come. It doesn't have to "match" the wedding being planned, but it shouldn't outshine the wedding. If the couple is planning an informal wedding, then the engagement party should be a casual event as well.

✻ **Who is invited?**

You may be tempted to share your joy with the whole world, but limit the engagement party to close friends and relatives of the bride and groom. Whether your idea of close is 10 or 100, make the list carefully, because guests whom you invite to the engagement party must be invited to the wedding.

✳ What's the right type of invitation?

Usually written, printed, or fill-in invitations are sent, but if it's a small, intimate gathering, phone or e-mail invitations are fine. Just be sure the invitation matches the style of the party.

✳ At the party, does anyone announce the engagement?

The party decorations may "give it away" before any official announcement, but typically the father of the bride welcomes everyone and "announces" the news in the form of a toast: "Mary and I couldn't be happier that Sarah and Matt have decided to get married. I'd like to propose a toast and wish you both a lifetime of happiness." Everyone except the couple raises their glasses. Next, the groom responds, expressing his happiness and thanking all the guests for coming. Then the father of the groom offers a toast to the couple or to the bride and her family. After that, other guests may propose toasts.

✳ When should gifts be opened, and are written thank-you notes required for gifts given at the engagement party?

When gifts are given by *everyone* at the party, then the couple opens them at the party (if there's time!) and expresses their thanks in person. If not all guests bring gifts, then the gifts should be set aside and opened afterward. Regardless of

whether the giver was thanked in person at the party, or the gift received and opened at another time, handwritten thank-you notes should be sent for all engagement gifts, as well as for any flowers or notes of congratulations received.

❊ Should we send printed announcements?

Printed announcements are sent immediately after a wedding. They're not sent to announce an engagement. The engagement announcement, if made, is done in the bride's and groom's local newspapers.

❊ When do I announce my engagement in the newspaper?

The announcement is placed in the paper after your family and close friends have been told your happy news in person, or on the day following an engagement party if that's how the news was shared. As with the word-of-mouth announcement, you don't want a good friend or your Aunt Joan reading about it in the paper and having hurt feelings.

❊ When is it in bad taste to announce an engagement in a newspaper?

If there's been a death in either family, or if an immediate family member is seriously ill, then no newspaper announcement should be made. Also, no public announcement is made

if either person is still legally married to another—no matter how imminent the divorce or the annulment.

✳ What's the general wording for a newspaper engagement announcement?

Most announcements are brief and follow a format similar to the sample below. Traditionally, the parents of the bride-to-be make the announcement, and the basic wording includes full names with courtesy or professional titles; city and state of residence if not the same as the hometown paper; highest level of education of the couple; and their current employment:

Mr. and Mrs. Henry Jameson of Fairfield, Connecticut, announce the engagement of their daughter, Mary Francis Jameson, to Arthur Wellgate Fielding, Jr., son of Doctor Anita and Mr. Arthur Wellgate Fielding of Morristown, New Jersey. A June wedding is planned.

Ms. Jameson, a graduate of the University of Pennsylvania, is an actuary with Connecticut General Life Insurance in Hartford, Connecticut. Mr. Fielding was graduated from Brown University and is employed as a Trust Officer with TD Banknorth of Hartford.

Some newspapers consider engagement announcements a public service; others may charge for them. Each paper has

its own style—concise or lengthy, formal or informal—which usually can't be altered.

✳ **My fiancé's family is from another town. Should an engagement announcement appear in his local paper? Should it be in his parents' name or in my parents' name?**

Ask your fiancé's parents if they'd like the announcement to appear in their local paper. If so, then send the same announcement used in your local paper to their local paper.

✳ **My mother died when I was quite young. My father wants to announce my engagement in the newspaper. Would my mother be mentioned in the announcement?**

When a parent is deceased, the surviving parent makes the announcement and the deceased parent is also mentioned:

Mr. David Lowell Manning announces the engagement of his daughter, Lauren Tilman Manning, to. . . . Ms. Manning is also the daughter of the late Alyson Tilman Manning.

❋ My parents are divorced. Which parent announces my engagement?

If the bride's parents are divorced, her mother usually makes the announcement, unless her father is the custodial parent. Divorced parents are listed as individuals, by their current legal names and place of residence, never as a couple.

Ms. Dawn Arden Boyce of Purchase, New York, announces the engagement of her daughter, Samantha Anne Caswell, to . . . Ms. Caswell is also the daughter of Mr. John Allen Caswell of Rye, New York.

If it's the groom's parents who have divorced, then the following is appropriate:

Mr. and Mrs. Anthony John Biaggi announce the engagement of their daughter, Francesca Maria Biaggi, to Timothy Norton Pease, son of Mrs. Anita Pease of Shaker Heights, Ohio, and Mr. Frank Dudley Pease of Grosse Pointe, Michigan.

Usually, a stepparent isn't included in a formal announcement unless he or she is an adoptive parent, or the natural parent

has no part in the bride's or groom's life. Stepparents are mentioned in lengthier or more informal announcements.

✳ As a gay couple, how do we announce our engagement?

Your announcement follows the same format as that of any other couple. One of your parents may make the announcement or you may announce it yourselves:

Ms. Samantha Percy Glick and Ms. Patricia Hart Ponti are pleased to announce their engagement. A civil union ceremony is planned for May. (Information about the couple and their parents may also be included, just as in a standard announcement.)

✳ How are second-time engagements announced?

If the bride-to-be is young, then it's traditional for her parents to make the announcement. An older woman or a woman independent of her family may make her own announcement with her fiancé. Usually, no mention of previous marital status is made unless the announcement is long enough to include details about children.

✻ What happens when an engagement is broken?

Here are some basic ground rules, both practical and considerate, which should be kept in mind:

- *Tell close friends and family as soon and as tactfully as possible.* Start with children and parents, and explain the break-up without demeaning the other person.

- *Don't expect family or friends to choose sides.* Some people will rally around or express sympathy initially, but it's an imposition to expect continued interest or participation in your very personal decision.

- *Inform everyone involved with the wedding as soon as possible.* Speak personally to all attendants, your officiant, and anyone who has planned a party in your honor. Friends and relatives can assist with contacting vendors.

※ **Should I place an ad in the newspaper to let people know that my wedding won't take place?**

No, a broken engagement isn't announced in the paper. You have three ways to let guests know the wedding is off. If there's enough time you can mail a printed card:

> *Mr. and Mrs. Carlos Hector Sanchez*
> *announce that the marriage of*
> *their daughter*
> *Rosaria*
> *to*
> *Mr. Ernesto Samos*
> *will not take place.*

E-mail is okay, too, if you're sure your guest will get the message. If time is short, then pick up the phone and start calling your guests. Talk to them personally or leave a voicemail message. Keep it short—there's no need to go into detail. It's fine to enlist family and attendants to help.

❉ What happens to the gifts if the engagement or wedding is called off?

All wedding, shower, and engagement gifts, including monetary gifts, must be returned to the givers. Possible exceptions are monogrammed items, gifts that the givers insist that you keep or gifts that were used, like a wedding planning book. In these cases, use your best judgment, but be sure to send the giver a note. If it's too difficult to return gifts in person, then they may be sent by mail with an accompanying short note:

> *Dear Robyn and Joe,*
>
> *I'm sorry to tell you that Frank and I have cancelled our wedding. I'm returning the silver bowl that you were so thoughtful to send.*
>
> *Sincerely,*
>
> *Grace*

Traditionally it was the bride's responsibility to return the gifts, but today this sad task is shared by the couple, with help from family members and attendants.

SMOOTHING THE WAY: *It's very important not to use engagement, shower, or wedding presents before the wedding—in the unlikely event that they might need to be returned.*

❋ My fiancé and I parted amicably. He hasn't asked for it, but should I return the ring?

It's best to return the ring even though, in most states, you don't have a legal obligation to do so. The ring was given as a token of a pledge to be fulfilled. Since the pledge was broken, do you really want to keep a constant reminder of the broken promise? After all, the ring isn't a consolation prize. Returning it shows that you place value on the relationship that you once had and not on its material symbol. The decision is yours and your conscience is your best guide.

If the ring is a family heirloom, there's no question: It should be returned, along with any jewelry you received while engaged. However, if you and your fiancé bought the ring together, then it should be sold and the proceeds split proportionately. Or, if one person wants to keep the ring, the other should be reimbursed for his or her share.

making plans

✳ **My fiancé and I have spent a lot of time dreaming about our wedding day. Now that we're engaged, we don't know where to begin planning!**

You don't have to pick the napkin color today, but you do need to make some fundamental decisions. First, establish a budget and a guest list. Then, choose the date—which also means checking on the availability of both the ceremony and reception locations as well as the officiant. Next, determine the overall style of your wedding. At this point, you may also want to consider hiring a wedding consultant.

✳ **My fiancé is helping me with much of the wedding planning, but my mom doesn't think that's appropriate. Is it proper for him to share in the planning?**

Yes, definitely! Gone are the days when the groom popped the question, selected his groomsmen, planned the honeymoon and showed up on the scheduled day on time. Even his boutonnière was someone else's choice! Today, grooms are likely to be active participants in making decisions and carrying out wedding duties, from setting a budget to hiring caterers to writing thank-you notes. More and more, the marriage partnership actually begins in the joint planning of the celebration that will join a couple together.

According to the Condé Nast Bridal Infobank, 40 percent of couples plan their weddings together and three out of four grooms help select items for their wedding gift registries. This heightened involvement has a lot to do with the fact that 75 percent of engaged couples pay for all or part of their own weddings and, as a result, grooms are more invested in what they're paying for and they want more input. So reassure your mom that it's perfectly proper.

✳ **I'm thrilled that my fiancé wants to help with the wedding planning—it takes a lot of stress off of me. Any suggestions for dividing up the duties?**

Unlike the traditional list of "who pays for what," your shared planning and responsibilities will have to be your own invention. Start by individually making a list of your top priorities. Place all the major aspects of the ceremony and reception (location, number of guests, wedding party, attire, invitations, music, flowers, food, drink, photography, videography, cake, transportation, vows) in order of their importance to you. Perhaps your number one item is your gown, while the groom's is the music. Then look at your budget and think about how you want to allocate your resources and what aspects of the wedding mean the most to you in terms of cost, effort, and consideration for guests. Making these lists and discussing what's important to each of you can help you decide who'll take the lead on certain items.

Most couples make the first-tier decisions together: Choosing the date and the ceremony and reception site; fixing the size of the guest list; agreeing on a budget; choosing attendants; deciding on the style of the wedding; and choosing an officiant. The second-tier decisions are usually divided, with one person taking the lead role in researching and choosing

the invitations, florist, caterer, photographer, and other details having to do with the ceremony or reception.

✳ Who pays for the wedding?

Up to 75 percent of weddings are paid for by either the couple or by some combination of the couple and the bride's and/or groom's parents. Couples today are older, and generally independent by the time they marry, enabling them to contribute to or to plan and pay for their own weddings.

Traditionally, the bride's family paid for the wedding, a custom derived from the ancient practice of providing a large dowry to attract a good husband. In Victorian times, the custom evolved into a settlement from the bride's family to the groom's, along with a trousseau—usually a year's worth of household items and clothing. Nowadays only 27 percent of weddings are paid for entirely by the bride's parents.

✳ Traditionally, which expenses are the bride's family's responsibility and which are the groom's?

If age-old tradition is ruling the financial structure of your wedding, the following are lists of the traditional expense responsibilities:

Traditional Expenses of the Bride and Her Family

- Services of a bridal consultant

- Invitations, enclosures, and announcements

- Bride's wedding gown and accessories

- Floral decorations: ceremony, reception, brides-maids, bride's bouquet

- Wedding photography or videography

- Music for the ceremony and reception

- Transportation of the bridal party to and from the ceremony and to the reception

- All reception expenses

- Accommodations for the bride's attendants

- Bride's gifts to her attendants

- Bride's gift to the groom

- Groom's wedding ring

- Extra expenses at the ceremony: awning, aisle carpet, sexton, soloists

- Traffic officer

- Valet parking

- Transportation and lodging for the officiant if from another town and invited by the bride's family

- Bridesmaids' luncheon, if given

Traditional Expenses of the Groom and His Family

- Bride's engagement and wedding rings

- Groom's gift to the bride

- Groom's gifts to his attendants

- Ties and accessories for the groomsmen and ushers, if not part of a rental package

- Flowers: Boutonnières for groomsmen and ushers, bride's bouquet (only if it's local custom for him to pay for it), bride's going-away corsage, corsages for immediate members of both families (unless the bride included them in her order)

- Marriage license

- Officiant's fee or donation

- Transportation and lodging for the officiant if from another town and invited by the groom's family

- Accommodations for the groom's attendants

- Transportation and lodging expenses for the groom's immediate family

- Transportation for the groom and best man to the ceremony

- Bachelor dinner, if the groom hosts one

- All costs of a rehearsal dinner

- Honeymoon expenses

SMOOTHING THE WAY: *Any conversation about money should be respectful and candid. Even though many families are willing to share the costs of a wedding, it should never be assumed that they are expected to do so. When families are willing to share the costs, the bride and groom should consider the range of possibilities ahead of time and be certain that they are in agreement with each other before sitting down with their parents to discuss the budget. If they want financial help, they must be willing to compromise on some of their wishes for the wedding.*

✳ **I'm the mother of the groom. I'd like to know what's going on with the plans, and is there anything I can do to help?**

Let your son and his bride-to-be know that you're willing to help and would love to be kept in the loop as they make plans. On your own, you can start by getting your guest list in order, respecting the budget and the number of guest allotted to you. Also, check in with the bride's mother to see what she plans to wear. Although it's fine for you to choose your own outfit based on your taste, it's traditional for the bride's mother to choose first and it's a plus if the mothers try to complement each other's look. But most of all, take a serious look at the expenses traditionally paid by the groom's family. Which ones do you feel you can take on? Let your son and his fiancée know how you'd like to contribute—financially or otherwise—so that they can plan accordingly. The more you communicate, the more likely you'll find opportunities to get involved.

✳ **I've asked my fiancé's mother to help plan our wedding, and she took that as an invitation to organize the whole event. How can I prevent her from taking over?**

Getting your future mother-in-law involved was a smart move. More often than not, this is a great way to get the relationship off to a solid start. Sit down with your fiancé and his mom to review

what's been done. Approve and appreciate the items that you're okay with, and gently let her know what you'll be handling and why. Don't have a showdown. Instead say, "Leslie, you've done a wonderful job with the caterer, but Chad and I want to handle these last few meetings so that we're familiar with the decisions you've made." Be resolute but appreciative, and leave her with some tasks—there's bound to be enough work for everyone!

✳ **My fiancé and I have definite ideas about what we want and don't want at our wedding. My mom is hosting the wedding, so I know she'll want to make the decisions. Should we offer to pay for the wedding so we'll have more control?**

You may certainly offer, but it may not come to that. You and your fiancé need to sit down with your mom and discuss your ideas. Give her a chance to tell you what she envisions; then let her know what you would like. She's excited about your wedding, too, so be empathetic and supportive and enthusiastic when your ideas are on the same wavelength. There's probably plenty of room to compromise, too. It's your day, so you should have the final say even if she's footing the bill, but the whole experience will be more enjoyable if your relationship with your mom isn't strained in the process. Try to love every idea for five minutes and think about how decisions will affect your relationship beyond your wedding day.

❊ **What expenses should we budget for when planning a wedding?**

Obviously, this depends on the size and complexity of your wedding, but the following categories form the basis for most wedding budgets:

- Invitations, announcements, and other printed material

- Postage

- Stationery for thank-you notes

- Ceremony fees: clergy, sexton, soloist, cantor, organist, musicians, rehearsal

- Legalities: license fee, health or blood test fees

- Transportation to the ceremony and to the reception

- Photographer and/or videographer

- Flowers: for the ceremony, reception, wedding party, and others (parents, grandparents, honor attendants)

- Gifts: for the wedding party, friends who help, to each other

- A party for the wedding party: bridesmaids' luncheon or bachelor dinner

- Lodging for the wedding party

- The bride's attire: gown, shoes, and accessories

- Wedding cake

- Reception costs: venue, catering (food and beverage), parking, tips

- Music for the reception

✳ **We've determined our budget categories, but have no idea how to assign costs to them. What's the norm?**

Every wedding is different. Some couples spend more on the cake than the bar, or more on the dress than the flowers. Whether you have a large or small budget, the following list shows the average percentage of the total budget spent on each category:

- Invitations: 1 to 2 percent

- Bridal attire: 3 to 5 percent

- Food and beverage for the reception (excluding the cake): 45 to 50 percent

- Wedding cake: 2 to 3 percent

- Reception entertainment, live band or DJ: 6 to 8 percent

- Photography: 9 to 11 percent

- Videography: 5 to 6 percent

- Transportation: 2 to 3 percent

- Other expenses: 2 to 19 percent

✳ At this stage, do I need to make a guest list?

Although your available budget determines the overall wedding, the guest list determines how most of the money will be spent. It's hard to make any other practical decisions about the wedding until you have an idea of the size of the guest list. If your guest list is large and your budget small, you may have to forgo a big formal sit-down dinner reception. Paring your guest list may allow it. The easiest way to cut costs is to cut the guest list.

✳ **I work full time and I'm realizing that I'm going to need help organizing my wedding. What can a consultant do for me?**

In general, a wedding consultant:

- Listens carefully and understands your wedding vision and then is your advocate to realize that dream in the best way possible

- Helps you set a budget and helps you stick to it

- Helps you locate and reserve ceremony and reception sites

- Helps you select and hire reputable suppliers and vendors: florist, caterer, musicians, photographer; advises you on vendor contracts; handles negotiations

- Advises you on the selection and wording of invitations, announcements, and other communications

- Coordinates communications between vendors, suppliers, and sites so, for example, the florist knows when and how to access the ceremony site to decorate

- Draws up a timeline to keep everyone on schedule, both pre-wedding and on the wedding day

- Serves as a referee, friend, budget advisor (and watcher), etiquette expert, shopper, detail manager, and organizer

- Coordinates your rehearsal with your officiant

- Supervises all the last-minute details of your wedding day

✳ What qualities should a good wedding consultant have?

Wedding consultants are known for saving their clients time and money. Some qualities to look for:

Experience. A good track record is the best guide, so check references and talk frankly with some of the consultant's previous clients.

Professionalism. The consultant should understand the business of weddings. Certification and/or membership in a consultants' association may indicate professional commitment.

Congeniality. A congenial consultant works with you; he or she isn't dictatorial and won't pressure you into decisions you aren't comfortable making.

Good chemistry with you. Is this someone you want to spend time with? Confide in? You should feel very comfortable with the consultant, considering how closely you will be working together.

Excellent listening skills. Your consultant will plan your wedding. Is this person a good listener, or does his or her plan sound like someone else's wedding?

Courtesy. A consultant's manners are an indication of how he or she will work with you and with others. This person will also be your wedding etiquette expert and represent you to your officiant, vendors, suppliers, site managers, and even members of the wedding party. You want to be represented positively.

❋ How far in advance should we book our ceremony and reception site?

Ideally, as early as possible. Popular venues can be booked more than a year in advance, so be prepared to be a little flexible on your date, if you can. If you're having the ceremony and reception at home, you have a little more leeway, but you'll want to be sure that your officiant and your caterer will be available.

✳ **We want to be married in a lovely little church near my hometown. Are there any "hidden practicalities" to consider?**

Whether it's a quaint hometown church or a romantic country inn, before you jump right in check with the officiant or site manager to determine what's permitted and what isn't and to ensure access for your vendors such as florists, musicians, and photographers. Here are a few questions to ask ahead of time so that you're not surprised later:

- Is photography or videography allowed inside the house of worship; is it allowed during the ceremony?

- May candles be used?

- Are there dress restrictions for the wedding party?

- Are decorations permitted, and if so, when may your florist access the site?

- Are there dressing or waiting areas?

- Is there guest parking?

- How do vendors access the site?

- Is there access for handicapped visitors?

- If the ceremony isn't in a house of worship, who supplies items for the service, such as an altar, kneeling cushions, or a *chuppah*?

❋ What should we discuss with our minister?

Depending upon your religion, the following is a general checklist of the points to cover in your meeting with your officiant:

- Reconfirm the date and time of the ceremony.

- Discuss whether your service will be traditional or if you can personalize your vows or include special readings or musical performances.

- Discuss the length of your ceremony, and for a Christian ceremony, if communion will be offered.

- Discuss the number of guests the site will comfortably hold.

- Let your officiant know if yours is an interfaith marriage. See if there are any restrictions.

- Discuss if you're planning to marry in a house of worship or at a secular site. Again, certain restrictions may apply.

- Schedule the wedding rehearsal and find out how long it will run.

- Ask if there are any requirements, such as premarital counseling, that you need to fulfill. If so, schedule those appointments.

- Ask if there are any clothing restrictions for the wedding party.

- Ask if you need to provide any documents or papers.

- Let your officiant know how you would like to be addressed during the ceremony.

- Discuss the fees and payment method for the site, the officiant, and any other participants, such as a sexton, organist, or choir.

❋ **I'd like to have the minister from my hometown marry us in the church we now belong to. What's the protocol for inviting him? I don't want to upset our current minister.**

This isn't an unusual request, but the first step is to talk to your local clergyman right away. Explain that your hometown minister is an old friend whom you've always wanted to be

involved in your wedding. In some cases, it's required that the local officiant be present and lead or participate in the service. In others, there's no such requirement and the visiting clergy may have the use of the church or synagogue. It's often customary to give a donation to the local clergyperson for his or her help in making the arrangements. In any case, take these steps to ensure that all goes smoothly:

- Check what the regulations are before asking out-of-town clergy to perform all or part of the ceremony.

- Get permission to use the house of worship.

- Send your invitation in a handwritten note.

- Coordinate communication between the out-of-town officiant and his or her contact person at your local house of worship.

- If the out-of-town clergy will be the sole officiant, get a list of any ceremony needs ahead of time.

- Pay the travel, lodging, and meal expenses of any clergyperson you invite from out of town.

- Invite him or her (and spouse) to the rehearsal dinner.

❋ **After we had several meetings with our second-choice officiant, our first choice suddenly became available. Would it be all right to switch?**

If it's getting close to your wedding date, or your second-choice officiant has done all the legwork necessary to bring you to the altar, it would be inconsiderate to change now. However, if you're still in the very early stages of planning your wedding and your first-choice officiant is someone near and dear to you or your fiancé (your childhood clergyperson or a relative, for example), explain the situation to the second-choice officiant in the kindest manner possible. He or she will surely understand.

❋ **In general, what are the steps in planning a reception?**

At the beginning, focus your planning on these major decisions:

- Where will you hold your reception?

- How will you work with your vendors?

- What type of food service will you have: passed hors d'oeuvres, buffet, waiter service?

- What type of beverage service: open bar or per-drink bar?

- Do you need to hire a caterer?

- How will guests be seated: assigned or unassigned?

- How will you and the wedding party get from the ceremony to the reception?

- Will you have music and dancing?

✳ **We have several members of our immediate family who "overindulge," especially at open bar weddings, so we want to limit the amount of alcohol served. Our reception site has a separate bar area. Is it acceptable for us to serve wine, beer, and champagne at our reception, but let them pay for any hard liquor drinks at the bar?**

Guests at a wedding shouldn't pay for anything—that's the host's responsibility. It's why cash bars and tip jars are considered taboo at wedding receptions and why the hosts should pay all valet, coat check, and restroom tips in advance so that guests are relieved of those obligations as well.

There's no rule that says alcohol must be served at a wedding. In your case, it sounds as if you have good reason to limit the amount and type of alcohol served at your reception. It's not necessary to have a full open bar and you're certainly meeting your obligations as a host by offering your guests beer, wine, and champagne, along with nonalcoholic options. Since

the bar is adjacent to but not a part of your reception area, guests who wish alternative refreshment can avail themselves at their own expense. You're right, they may drink a little less if it's not freely available.

✳ How do I know if I need a caterer?

If you're planning a small reception and have the help of family and friends, you probably don't need a caterer. When you keep the menu and decorations simple and prepare food ahead of time, a small reception can be inexpensive and reasonably easy to manage.

But if you're planning a larger reception at home or at a site that provides no food service, doing it yourself can be a lot of work. Entertaining a large number of guests requires a caterer if you are going to be able to successfully host the reception. Hiring a caterer is recommended for a reception of more than thirty guests. Caterers, in other words, let you be a guest at your own party.

✳ Do caterers just take care of the food?

Depending on the size of the company, they can provide just the food or supply the works: food, beverages, wedding cake, serving staff, crystal, china, flatware, table linens, tables and chairs. Some even provide tents, dance floors, and decorations, or can recommend reliable suppliers and vendors.

✱ How soon should I meet with photographers, videographers, and musicians?

Meet with and select these professionals as soon as possible after securing the ceremony and reception sites. Wedding seasons book up fast, and you'll want to have the best chance at hiring the professionals you want for your particular dates.

✱ I know I need to set aside money for tips, but I'm not sure who to tip and when.

In general, wedding professionals such as consultants, club managers, caterers, photographers, florists, or musicians are tipped only for extra-special service. A handwritten thank-you note to a wedding professional is a thoughtful gesture, especially to one who has done an excellent job. Often a caterer's gratuities are embedded in the total costs, and many hotels include a service charge for waitstaff. Always ask if gratuities are included, and for whom, before signing any contract. If they're not, expect to pay 15 to 20 percent of the total food and beverage bill and for other services that were provided. If the bartender is hired separately, he or she is tipped 15 to 20 percent of the bar bill.

The limousine driver's tip is usually included in the hire. Tip floral, bakery, and other delivery-truck drivers $5 to $10

each for deliveries. Again, check the contracts to be sure. Plan for tips for valet parking, coat check, and powder room attendants—generally a flat fee or $1 to $2 per guest.

Tips are given on the day of the wedding. It's a good idea to have some extra cash just in case you choose to thank someone for especially outstanding service. Give one of your attendants a list of your vendor contacts and ask him or her to deliver the tips for you at the end of the reception. Consider tipping parking, coat check, and powder room attendants ahead of time so that your guests don't have to, and instruct valet parkers to tell guests that there is no tipping. Ask a friend to make sure that there are no tip jars or baskets that would make a guest feel obligated to tip in the coatroom, powder room, or bar.

✽ **Friends have given me recommendations for local florists, musicians, and photographers. How do I select the right ones for me?**

You've started well by getting recommendations from friends. But it's important to check references and talk to other brides about their experiences working with these professionals. When you have your list of recommendations, make appointments with the ones who sound promising. Let them know up front that you're not ready to sign a contract. This is an opportunity for you to review their portfolios or listen to samples

of their music and ask about their experience in working at your ceremony and reception sites. Be prepared to share your overall vision as well as a providing a list of your particular needs.

If their work is a match for your vision, then two other factors guide your decision: price and compatibility. Remember, you're building a team that needs to work well with you and, in some cases, with each other. Having someone you enjoy working with and can communicate with easily is invaluable. Trying to work with someone whom you don't connect with can cause stress and headaches that may not be worth a lower price.

And if two vendors appeal to you equally? Ask the people you interview how they feel about weddings to see if they're truly enthusiastic and dedicated, or if this is just another job.

❋ I'm nervous about signing the vendor contracts. Is there anything I should watch out for?

Before you sign any contract, be sure that you've read and understood everything, especially the fine print, and assume nothing. The whole purpose of the contract is to try to foresee any possible problem or situation that might arise, and to make sure that everyone is on the same page about how it will be handled and whose responsibility it is. That way, there

won't be any surprises when it comes time to pay. Don't be afraid to ask questions, or to have something repeated until you are clear. Before you sign, be sure you ask for:

- An item-by-item breakdown of all services and prices so you know exactly what you are (and aren't) getting

- All deposits and payment schedules

- Whether gratuities and/or taxes are included

- What you will be charged if the event runs overtime

- Whether breakage insurance is included

- What the cancellation policy is

❋ What can be done with flowers from the church and reception after the wedding?

If you have no plans to use the flowers again, recycle them! The ceremony flowers can be left for the next worship service. Ceremony and reception flowers can be given to guests to take home, or you can arrange to have them delivered to local nursing homes, hospitals, charities, or public buildings such as the

library or town hall. Another idea is to have an arrangement delivered to a loved one who was unable to attend the wedding, accompanied by a little note from you.

✳ I've just found out that our ceremony site doesn't allow any kind of photography during the ceremony. What can I do?

First, check to see if simulated photographs can be taken either before or after the ceremony. If the ceremony photographs can be staged before the wedding begins, they should be completed at least an hour before the ceremony starts. You don't want photos being taken while guests are being seated. If you're having them taken between the ceremony and the reception, keep it brief! Focus on key shots, not a rerun of the entire ceremony. You don't want your reception guests getting restless.

✳ Do we provide dinner for musicians and photographers at our wedding?

As a general rule, if you're serving a meal to your guests, then you should feed your vendors as well. Many reception sites have a separate area where your crew can eat. Often the caterer will serve them a less expensive meal than the one guests receive, or the same meal at a discounted price. Be sure that vendor meals are part of your catering contract, to avoid sur-

prises later. When planning your reception, determine the best point for the band and others you've hired to take about a half-hour dinner break.

✻ My mom is lobbying for live music, my fiancé wants to use his iPod, and I'd really like a DJ. Do you have any advice?

First, you'll need to sit down and give everyone a chance to say why they want one over another. The most cost effective, obviously, is using an MP3 player. The other advantage is that it can be loaded with all your favorite music, and/or music that appeals to several generations. If your fiancé is confident that he can put together a great playlist, this could be a viable option. Cost containment, again, is an advantage to hiring a DJ. Plus, a DJ can offer a larger playlist, play specific requests that may not be in a musician's repertoire, and double as a master of ceremonies. Make sure you listen to the DJ in action—and take your mom and fiancé with you. Then again, there's nothing like dancing to a live band. One that provides a good range of music and a lot of enthusiasm can keep the dance floor full all night! Again, try to work out a compromise that will provide the music and the atmosphere you're hoping for.

❋ **E-mail has been especially helpful in setting appointments with vendors and keeping in touch with my bridesmaids. When is e-mail okay to use and when isn't it?**

E-mail is fine for:

- An informal "save the date" notice to close friends and family.

- Invitations to informal or casual engagement parties, showers, and other pre-wedding get-togethers. Just be sure *all* your invitees use their e-mail on a daily basis, and don't send out a "group e-mail"—send invitations individually.

- Information on lodging or maps and directions for out-of-town guests. This is a great use of the group e-mail option and "Dear All."

- Wedding updates. Use this judiciously and don't overwhelm your audience with daily news flashes.

- An optional RSVP on your invitation. Just be sure it's an option! Add the following on a line after the RSVP: "If you prefer, you may reply by e-mail to happycouple@rsvp.com." This is a great choice for an informal wedding or if the wedding is taking place on short notice.

- Wedding announcements, particularly if you and the recipient are on informal terms or if the wedding itself was informal.

E-mail isn't appropriate for:

- Wedding invitations. A printed or handwritten invitation sent through the mail is the only way to extend such a personal invitation. The only exception is when the wedding takes place on very short notice.

- Thank-you notes. All thank-you notes must be handwritten and mailed—no exceptions. If you've fallen behind, you can use e-mail as a stopgap to notify the giver that you've received the gift, but you must follow up with a note.

- Personal or delicate communications. Not only is e-mail not private, it's not a good medium for working out compromises or resolving conflicts. Tricky issues should be dealt with face-to-face or over the phone.

- When the groundwork hasn't been properly laid. While it's convenient to send group e-mails about wedding-related plans, check your plans personally

with other key people before announcing them to the world and ruffling feathers.

✳ We'd love to create a wedding Web site. What are good things to include?

Personal wedding Web sites can be "info central" for you and your guests. You can post photos, information on lodging, maps and directions, planning updates, the option to RSVP electronically, and even links to department store or Web-based gift registries. Wedding planning sites like Wedding Channel (www.weddingchannel.com) and The Knot (www.theknot.com) offer wedding advice and step-by-step instructions for designing your own free Web page, reachable through their Web addresses. Other Web sites allow you to create a site at your own Web address for a fee. Whichever you choose, remember:

- Take some time to choose a design and content that reflects your personal style.

- Keep it simple: a few well-designed pages will speak volumes.

- Keep it tasteful: you want your visitors to feel welcomed and comfortable.

- Don't include overly personal information. Some predesigned templates encourage you to share overly personal information. Save it for the bachelor(ette) party.

- Don't overemphasize your registry links.

- Use it judiciously for wedding updates; don't overwhelm your audience with daily news flashes.

- If you'd like people to have the option of RSVPing on your site, simply add the following line below the RSVP on your invitation: "If you prefer, you may reply at www.happycouple.com."

- Don't list your Web site on your actual invitations. It's fine to add your Web address to other enclosures in the invitation package, such as the response card or map.

- Remember your off-line guests; not everyone has ready access to the Internet.

- Do post wedding or honeymoon photos on your site, as well as a general, heartfelt thank-you. The general thanks, though, doesn't take the place of writing personal notes for gifts or favors done for you.

CHAPTER 3

choosing your attendants

❋ **When do we invite attendants to be in the bridal party?**

Three to six months before the wedding date is pretty standard. Attendants can organize their calendars, purchase clothing and have alterations made, arrange transportation, and plan and host any parties they wish to hold in your honor. Ask in person, if possible. Otherwise call, write, or e-mail your invitation. Include the wedding date and location as well as some sense of the formality of the wedding. Don't be taken aback if the person doesn't accept immediately. Yes, it's an honor, but it's also a big responsibility as well as a financial commitment, so give your prospect a chance to think it over.

✳ Who should we ask?

Most people ask siblings, close relatives, and good friends. Take time to consider the important qualities of a good attendant:

Reliability. Will they listen carefully to instructions, follow up on requests and show up on time for events?

Consideration. Will they offer thoughtful suggestions but not expect to be in charge? Will they be helpful, and not make special demands or offer needless criticism?

Courtesy. Will they serve as good ambassadors, mingle with guests at events, make introductions, look out for people with special needs, and behave appropriately at all times?

✳ When I asked a close friend to be a bridesmaid, she turned me down. I'm really hurt that she said no. I thought this was one invitation you were never supposed to refuse.

Even though it's a great honor to be asked to be a bridesmaid or a groomsman, people may have other obligations and accepting may not be possible. Despite your disappointment, you shouldn't be offended or expect a detailed explanation. A refusal is often

based on important family, job, or financial concerns, so be sensitive and accept her decision graciously. Remember, this is your good friend and you don't want to jeopardize your relationship.

✳ My cousin is overweight and my aunt doesn't think she should be a bridesmaid. Should I ask her anyway?

If you're close to your cousin and want her in your wedding, by all means ask her. Pregnancy, disability, height, weight, or physical appearance shouldn't affect your decision.

✳ In general, what are our attendants expected to do?

The attendants' primary responsibility is to see that the wedding and reception run smoothly. They're expected to be gracious and visit with guests, assist the elderly and anyone else who needs help, be attentive to young children in the wedding party, be available for picture taking, and generally help out where needed. If there's a formal receiving line, all or some of the bridesmaids may be asked to participate. In addition to specific duties for the particular kind of attendant, their basic duties are the same:

- To attend prenuptial events

- To follow instructions

- To arrive at specified times for all wedding-related events

- To assist the bride and groom

- To be attentive to other guests at the wedding and reception

❊ What are an attendant's financial commitments?

Expenses can add up quickly, so the wise bride and groom will take into consideration what kind of financial obligation they're asking their attendants to incur. For a close friend, you may even make a private arrangement to foot all or some of the bill. In general, attendants pay for:

- Their wedding attire and accessories (excluding flowers), either purchased or rented

- Transportation to and from the city where the wedding takes place. (The bride or groom's family arranges and pays for accommodations or houses the wedding party with friends.)

- The bridesmaids' gift to the bride or the groomsmen's gift to the groom

- An individual wedding gift to the couple or a contribution to a joint gift (if being in the wedding isn't the gift)

- Hosting or sharing the cost of a pre-wedding party, such as a shower, bachelor dinner, bridesmaids' luncheon, or a bachelorette party. This is nice, but by no means mandatory.

- A shower gift, if attending a shower. (If attending more than one shower, a gift is only required for one.)

❋ Is there any rule about how many groomsmen and bridesmaids we may have?

No, there's no required number, nor do there have to be an equal number of bridesmaids and groomsmen. The average is four to six, but some weddings have only one or two and others as many as ten.

❋ I can't choose between my two best friends. Can I have two maids of honor?

Sure! If you can't choose between two friends or two siblings, it's fine to have them be "co-maids of honor," sharing the duties—and the fun.

✳ My best friend is a man. I want him to be my "maid of honor." Is this all right? What should he be called?

"Honor attendant" is the name for an attendant of the oppo-site sex. Today many brides and grooms seek to pay tribute to their closest friends or brothers and sisters by including them in the bridal party in this unique way. Honor attendants perform the same duties as the maid of honor or the best man. Some of the traditions may have to be altered to fit circum-stance. It's not likely that a male honor attendant would help the bride get dressed! But these are details that can easily be addressed or altered. The most important factor is that your honor attendant be completely comfortable with his or her role, or the special meaning will be lost.

✳ Is it obligatory for me to have my fiancé's sister as my bridesmaid?

Perhaps you're thinking that you don't know her well enough to include her as a bridesmaid, but you might want to reconsider. While you're not obligated to ask her, the long-term benefits of family harmony may outweigh the potential harm and hurt feelings that not asking her would cause. She's about to become a part of your family—and you a part of hers. This is a great opportunity to get to know her better. It's a good bet that your future in-laws would appreciate such an inclusive gesture.

✳ **My fiancé and I are considering a destination wedding. Should we cover the costs of our attendants' travel expenses?**

Just like a traditional wedding, your attendants pay for their transportation and the bride and groom or their families pay for the accommodations of the wedding party. Of course, you may choose to cover their transportation as well. When extending your invitation, let your attendants know the financial arrangements so they can make a decision, especially if it's to an exotic destination.

✳ **In addition to the common responsibilities for all the attendants, what are the particular responsibilities of . . .**

. . . the maid of honor?

The maid or matron of honor is the bride's "best person," her right-hand woman. She helps the bride select the bridesmaids' attire, helps address invitations and place cards, organizes the bridesmaids' luncheon, if there is one, and the bridesmaids' gift to the bride. During the ceremony, she holds the groom's wedding ring and the bride's bouquet. At the end of the ceremony, she rearranges the bride's train and veil and returns the bouquet. She witnesses the signing of the marriage certificate. During the reception, she stands in a receiving line, gathers

guests for the cake cutting, dancing, and bouquet toss, and she may give a toast. Finally, she helps the bride change into her going-away clothes and takes care of the bride's wedding dress and accessories after the reception.

...the best man?

By far, the best man has the most responsibilities of all the attendants. He organizes the bachelor party for the groom, if there is one. He coordinates the groomsmen's and ushers' gift to the groom. He assists the groom in choosing the wedding attire, and in coordinating fittings or clothing rental for the other groomsmen and ushers. He sees that the groomsmen and ushers arrive on time and are properly attired, and he instructs them in the correct seating of the guests, if there's no head usher. He keeps the bride's wedding ring during the ceremony and witnesses the signing of the marriage certificate. He makes sure that the groom's wedding-related payments are prepared and he delivers those payments to officiants, assistants, musicians, and singers at the ceremony. He offers the first toast at the reception, and dances with the bride, the mothers of the couple, the maid of honor, and other female guests. He drives the bride and groom to the reception if there's no hired driver, and has the car ready—with luggage stowed—for the couple to leave the reception and, if necessary, he drives

them to their next destination. He gathers and takes care of the groom's wedding clothes and returns any rental items the next business day.

...the bridesmaids?

They should give their full cooperation regarding fittings and purchase of their wedding attire and accessories. Often, bridesmaids host an event for the bride—a shower, bridesmaids' luncheon, or bachelorette party—but none of these events is a requirement. They attend a bridal luncheon hosted by the bride, if given, as well as the rehearsal and the rehearsal dinner. They assist the bride at the reception as requested: standing in a receiving line; supervising any children in the wedding party, such as the flower girl or ring bearer; dancing; and participating in the bouquet toss.

...the responsibilities of the groomsmen and ushers?

Groomsmen stand with the groom during the ceremony. Ushers help prepare the wedding site for the ceremony and escort guests to their seats before the processional begins. Groomsmen may also be ushers, and this is usually the case at most small to medium-sized weddings. The rule of thumb is "one usher to fifty guests," so if the wedding is very large or the groom has few attendants, then additional ushers may be

needed. These ushers are seated in the congregation. Sometimes an older relative or family friend is asked to be head usher. His duties include supervising the ushers, managing latecomers, and seeing that all pre- and post-ceremony tasks are completed. The head usher, or the best man if he is doubling in that role, instructs the ushers in seating guests and the correct order for seating family members.

Groomsmen and ushers attend the rehearsal, the rehearsal dinner, and the bachelor party, if the groom gives one. They're responsible for knowing the seating order, especially the seating of important guests and family members. They greet guests, escort them to their seats, and hand each guest a program, if one is available. Right before the processional, the ushers lay the aisle runner, if one is used, and then walk in the processional.

After the recessional, they remove pew ribbons, close windows, retrieve programs or other left articles, and help guests who need directions to the reception site. At the reception, they dance with the bride, bridesmaids, and any single girls. Finally, they coordinate the return of rental clothing with the head usher or best man.

❋ What do we do if one of the attendants backs out right before the wedding?

Traditionally, once an attendant accepted the role, only illness or a death in the family was reason to back out. Today a critical business trip or work-related issue can force a groomsman or bridesmaid to have to step down. If this happens early in your planning, before the names of all the attendants have been announced, you may ask someone else to fill the role, a close friend or relative whom you think would be honored by the invitation. It's a kind gesture to absorb any costs of his or her participation, as the substitute wouldn't have been expecting such a potential blow to the budget. If an attendant cancels right before the event, then carry on without that attendant. Usually, issues involving the processional or table seating can be easily rearranged.

❋ Are there age limits for flower girls, ring bearers, junior ushers, and junior bridesmaids?

Flower girls and ring bearers are usually between three and seven years old. Junior ushers and bridesmaids are generally between seven and fourteen years old.

✱ **I'd like to have my five-year-old niece be my flower girl. What will she need to do?**

Flower girls are usually young relatives of the bride or groom. The flower girl precedes the bride down the aisle, either holding a small basket of flowers or a tiny nosegay similar to the attendants' flowers. If she's old enough, or confident enough, she may carry a basket of petals that she sprinkles in front of the bride as she walks down the aisle. During the ceremony, the flower girl either stands with the bridesmaids or sits with her parents or the bride's parents. The flower girl's parents pay for her dress and accessories (excluding the flowers). She attends the rehearsal, but usually not the rehearsal dinner.

✱ **What does the ring bearer do?**

The ring bearer walks down the aisle after the bridesmaids and ahead of the flower girl, carrying the wedding ring (pinned) on a small cushion. He stands with the groomsmen or sits with his parents or the groom's family during the service. He exits with the flower girl, if there is one—but if one or both of these young attendants has fallen asleep or is reluctant to continue, by all means, skip the formal exit!

✳ Do junior bridesmaids or junior ushers have any special responsibilities?

If there's more than one junior usher, they're usually put in charge of rolling out the white carpet or positioning the pew ribbons. Otherwise, they attend the rehearsal and participate in the processional and recessional. They're dressed like the regular ushers and walk behind them.

Junior bridesmaids attend the rehearsal and walk in the processional and recessional after the bridesmaids. They stand in the receiving line only if the bride requests it. If old enough, they're invited to showers.

The junior attendants' parents are responsible for purchasing or renting their wedding outfits and accessories, except for flowers. They either give a separate gift to the couple or are included in their parents' gift. Junior attendants aren't usually invited to the rehearsal dinner, but may certainly be included if mature enough.

✳ My future stepdaughter is seven and her brother is nine. How can we involve them in our small wedding?

Second weddings, whether for the bride, groom, or both, are about building a family, so it's important to try to include your children in the wedding ceremony. You could ask your fiancé's

son to be a junior usher and his sister to be a junior bridesmaid or flower girl, depending on her temperament. It's a wonderful way for all to be together when beginning this new family.

✻ **We can't have all our closest friends and brothers and sisters in our wedding party. Are there other ways to let them know they're special to us and have them involved?**

It's understandable that you just can't have everyone in the wedding party. To honor these special people, ask them to read a passage at the ceremony, serve as a guestbook attendant, greet and help guests with their seating assignments at the reception, or feature their special talents as a musician, poet, or photographer.

✻ **One of our ushers has a scruffy beard and could use a haircut, too. He's a wonderful guy, but how do we ensure he's properly clipped and styled for our big day?**

Just as you wouldn't dismiss a bridesmaid who's gained a few pounds, you can't force your usher to adopt different personal grooming habits for your wedding. Yes, it's worrisome to think that he'll stand out negatively, but give the guy some credit. No doubt he grasps the seriousness of the day and will likely surprise you by rising to the occasion. If you really feel the need to say something, ask your fiancé to apply some benevolent coercion: "Mark, you're gonna shave for the wedding, right

buddy?" If he doesn't clean up, so be it. Focus on what matters most: that those you love are there to stand beside you.

✳ I'm going to be a bridesmaid in a couple of months, but the bride is making us crazy with her instructions: color and brand of lipstick, eye shadow, and nail polish. We're all supposed to wear updos and have our hair and nails done at one very expensive salon. Our shoes are close-toed, but she expects us to have pedicures. She's even asked one bridesmaid to have her ears pierced and another to get her hair highlighted. What can we do?

Whoa—sounds like Bridezilla's on the loose, and it's not okay. It's understandable that brides want their wedding day to be perfect, but some get carried away and obsess about details. It could be worse—some brides have told attendants to lose weight, have teeth capped, hold off getting pregnant, or undergo skin treatments before the wedding.

You and the other attendants should meet with your bride now and talk about your issues. Be as kind as you can—she honestly may not be aware that her demands are excessive—but let her know you're united. Give clear and rational explanations for your objections and look for some compromises: You'll be glad to discuss makeup and hairstyles, but the final choice is up to each of you. If you bring up costs, the bride may say she'll foot the bill and then you're back to square one.

Be prepared for positive and negative comments. And don't forget: A few well-deserved compliments can do wonders. Give her time to calm down and think it over. If she still insists on having her way, you have two choices: Go along graciously (it's only one day) or resign. Hopefully it won't come to that, but if it does, avoid blaming it on her.

SMOOTHING THE WAY: *If you're thinking about having your bridesmaids sign a contract,* don't—*not even in jest. It may seem like the easy way to make sure that they perform their duties or agree to your ideas regarding appearance or the parties they may host for you, but it violates the fundamental principles of etiquette: consideration and respect. The considerate bride is genuinely appreciative of all that her attendants do for her, and is respectful in her requests of their time and resources. The relationship between the bride and her attendants is a purely social one, not a business one.*

CHAPTER 4

creating your guest list

✳ How do we determine how many people to invite?

A guest list is a magic number of family and friends that:

- Suits the size of your ceremony and reception sites

- Corresponds with the level of intimacy desired for the wedding

- Can be accommodated within your wedding budget—an important reality

✳ How do we divide the guest list?

The couple and their parents will have to work together toward an agreeable solution. Most do it in one of two ways:

- They divide the list into equal thirds, with the bride and groom, the bride's parents and the groom's parents each inviting one-third of the guests.

- Or the bride and groom reserve half the list for themselves, with the other half divided equally between the bride's parents and the groom's parents.

✳ Are there any guests who must be invited?

Yes. When making your list, don't forget to include the person who performs your ceremony and his or her spouse, the parents of ring bearers and flower girls, and the spouse, fiancé(e) or live-in partner of each invited guest or attendant, even if you've never met. Don't forget that engagement party guests and shower guests (except for office showers) are wedding guests. Keep this in mind when you're asked to draw up a guest list for other wedding parties.

✳ **We have to trim our guest list. We're having a difficult time and we're afraid of offending relatives and friends. Is there a way to do this without hurting feelings?**

It's easier to trim a guest list when you make decisions that go across the board. One way to do this is to arrange your guest list in tiers:

First tier: Immediate family: parents, stepparents, siblings, stepsiblings, grandparents, the couple's own children.

Second tier: Extended family members: aunts, uncles, cousins, nieces, nephews.

Third tier: Family friends: parents' close friends, long-time friends and neighbors, childhood friends and their parents (if close to you).

Fourth tier: Bride and groom's friends: childhood friends, high school and college friends, work and new friends. Rank these in order of closeness to you.

Fifth tier: Parents' colleagues: associates, employers, employees.

You can omit an entire tier, or a group or groups within tiers. This makes it much easier to explain, if you need to.

✳ Our family has a number of small children and a handful of teenagers. Can we just invite the teens? How do we avoid upsetting the parents of the younger ones?

Setting an age limit is a good way to make the distinction. Your parents and other family members can help spread the word that only teens will be invited to the wedding, so the parents of the younger ones won't be expecting them to be invited. You could call or send a note to those who you know might be upset, making clear that costs, space, the setting's formality, or some other circumstance prevents you from including young children. Once you've reached your decision, make no exceptions. It's a nice gesture to put together a list of reliable babysitters for those traveling to the wedding and who can't leave their kids at home. Despite your best efforts, some parents may still be offended. If that happens, so be it. You've done your best to be tactful and logical about expressing your needs.

✳ Must we invite the children of our guests to our wedding?

No, you are not required to invite your guests' children to your wedding. Unfortunately, some guests either truly misunderstand or choose to ignore the polite omission of their children's names

on the wedding invitation and write or call to tell you that they are bringing the kids. Then you'll have to have a direct conversation with the parents: "I'm sorry, Gina, but we're not having children at our wedding. We won't be able to accommodate Leah and Derek." If this results in an angry "Well, I'm not coming either," so be it. The breach of etiquette is theirs, not yours.

❋ Do we need to let all of our single guests bring a guest?

If your space and budget will allow it, it's a very nice thing to do, but no, it's not required.

❋ A friend has just called me to ask if she can bring a guest to our wedding. I was flabbergasted. I told her I'd have to call her back. What should I say to her?

It's pretty straightforward: It's impolite of a guest to ask if he or she can bring a date—but it's not impolite of you to refuse. Call her back and say, "Susan, I'm sorry, but we have limited seating at the reception and we just can't accommodate extra guests." However, if you find out she's engaged or living with this person, then try to make an exception and invite your friend's partner, either verbally or by written invitation.

✳ **Is it ever acceptable to invite one member of a married couple without inviting the spouse?**

No, both members must be invited, even if you only know one of them.

✳ **May I invite only one member of an unmarried couple who are living together?**

No, both should be invited. You may use a single invitation addressed to

>*Ms. Francine Novak*
>*Mr. George Berkley*

using two lines.

✳ **I sent an invitation to a friend and just found out that he's living with someone. What do I do?**

It's best to find out her name and address and send her a separate invitation. If you've run out of invitations, send her a personal note explaining that you were unaware, but that you'd be delighted if she would attend as well.

�֍ **My fiancé and I are only inviting sixty people to our wedding, but many friends and relatives we weren't planning to include seem to be inviting themselves: "Let us know when you set the date—we're really looking forward to it!" How do we tell them they won't be invited?**

Get the word out quickly that your wedding will be very small. Also, be sure you make up your guest list very carefully using clear-cut criteria to determine who's in and who's out. You might consider hosting another celebration after the wedding for all those good friends and family members whom you didn't invite to the wedding but who clearly want to toast your happiness.

✖ **Can we have a "standby" guest list to fill in for guests who send back regrets?**

A standby guest list is a risky proposition. The potential for people discovering this and feeling hurt can be great. If at all possible, invite the entire list at the same time. Typically, 10 to 20 percent of invited guests send regrets, so your master list can conservatively accommodate an extra 10 percent.

❋ I'd like to invite my congregation to attend my wedding. Should I also invite them to the reception?

No, in this case, they don't have to be invited to the reception. Usually, you wouldn't invite a large number of people to your ceremony and only a select few to the reception. But when you've asked your officiant to invite the congregation—usually an announcement from the pulpit or an invitation in the bulletin—it doesn't obligate you to invite everyone to the reception. An open invitation carries no gift obligation, either. Printed or written invitations to the reception are sent to family and friends.

❋ My coworkers are really great and I'd like to invite them to my wedding. Can I just post an invitation on the bulletin board?

You may want to think this through a bit. If you post an invitation on the bulletin board, you're essentially inviting anyone who might see it *and* their spouses, fiancé(e)s, live-ins, and children. Is that what you're really intending? If it is, then go ahead, but consider adding an RSVP sign-up sheet with a deadline so you'll know how many to expect.

❋ What if I want to invite some coworkers and not others?

You'll need to be tactful. Send the invitations to your office friends at their home addresses, not to the office. In your

enthusiasm about your wedding, be careful not to give the impression that you're inviting everyone from the office. Keep the wedding talk to a minimum, or discuss it with your office friends outside of work.

❋ **We sent save-the-date cards and now realize we need to cut back our guest list. Is there any way to politely "un-invite" some people?**

There really isn't. A save-the-date means that an invitation will be coming and your invitees will be expecting one. Rather than changing your guest list, look for ways to change your reception plans. Have a simpler, less expensive wedding by scaling back wherever you can on the reception.

❋ **We'd like to get married in Hawaii and have our honeymoon there, but our families and friends live on the East Coast. Who do we invite?**

You can invite whomever you wish, but you can't expect all of your guests to be able to afford the trip. Even if they could, many may not be able to schedule that much time off. So be realistic. Do you want lots of friends and family at your wedding, or will you be happy having just your immediate family, attendants, and a few close friends? You can always have a

small, intimate destination wedding and then host a party for friends and relatives after you return.

✳ **My parents are paying for our wedding, but my fiancé's parents just gave us their guest list and it exceeds our numbers and budget by thirty people. Is it okay for us to ask them to pay the added expense?**

If you simply can't afford the extra expense, speak to your future in-laws. Your fiancé, possibly with you present, can tell them candidly that your parents have set a budget and that the longer list exceeds it. Keep in mind that any conversation about money should be respectful and sensitive. It's not polite to ask that they pay the added expense. However, if they offer this as a solution, it's fine to accept. Another alternative is for his parents to host a second reception at a later date for friends who couldn't be invited to the wedding itself.

✳ **My parents would like to invite many of their friends to my wedding, but I don't want the celebration to be dominated by their guests. Is it fair to limit them to a certain number, even though my dad's paying for the wedding?**

You'll need to talk this over with your parents. Honestly and calmly tell them that you'd like to balance the guest list with some of your friends, your fiancé's friends, and his family's

friends, too. While it's perfectly reasonable to include your parents' closest friends and business associates, it's your wedding and not an opportunity for business and social paybacks. Don't be afraid to speak up, but listen with an open mind. You and your parents might reach an easy agreement—or you both may end up making some compromises.

✳ **My fiancé and I are having a very small wedding and only inviting thirty-five people. My father is very upset that we're not inviting his two brothers. He isn't close to either, and I really don't know them. Should we invite them?**

Even though your wedding is small and intimate, inviting them would mean a lot to your father and would be the gracious thing to do. They may or may not accept the invitation, but you would have offered them the opportunity to be there.

✳ **I'm still really close to my ex-husband's parents. Would it be okay to invite them to my wedding?**

When done for the right reasons, it's fine to invite your former in-laws. If they are devoted grandparents to your children or if you've remained close friends, it would be a nice idea to include them. Make sure you check with your fiancé first. If it makes him uncomfortable, then don't do it.

✳ My ex and I get along very well. Should I invite him to my wedding?

This is probably not a good idea, for several reasons. Friends can feel awkward celebrating a new marriage when the former spouse is there. Other family members need to be considered, too, and a wedding shouldn't be a time to open old wounds. But most important, think about your new spouse and any children you both bring to the marriage. It can be difficult and confusing for them to celebrate their new family when a former spouse is present. So, even though you may be on the best of terms with your ex, it's best to leave him or her out of the festivities.

✳ It's three weeks before the wedding, and I still haven't heard from a number of guests. What's the right way to handle this breach of etiquette?

Unfortunately, you're not alone. At this date, you have no choice but to call those who haven't yet responded and ask whether they're coming. Your mother, fiancé, future mother-in-law, or your attendants can help you make the calls. Yes, it's an awkward conversation, but be friendly, and say something like, "Sonia, it's Kathleen. I'm calling to make sure you received your wedding invitation. I haven't heard from you, and I hope you and Alex will be able to join us!"

the honour of your presence: invitations and announcements

*i*nvitations can cause anxiety because everyone wants to "get it right." The traditional wedding was hosted by the bride's family and the wording was fairly standard, but today, weddings are hosted by the couple, by a combination of people, or by divorced and remarried parents. So many questions begin: "How do I word the invitation when . . . ?"

❋ How far in advance of the wedding are invitations sent?

Invitations are sent six to eight weeks ahead of the wedding date.

❊ When should the invitations be ordered?

To place your invitation order, count backward from your mailing date. Plan on at least three to four months for printing and delivery of formal invitations, enclosures, and envelopes. Nontraditional invitations may take more time, so check with your stationer. Even if you decide to handwrite or laser print your invitations, give yourself enough time to select attractive paper and prepare your design. In addition, schedule an extra two weeks to address, assemble, and double-check them. A few extra "just in case" days added to the schedule can make a big difference if there is some unexpected delay. Factoring all that in, plan to order your invitations six to eight months before the wedding. If you have less time, be prepared to make some compromises.

❊ What's the traditional style of an invitation?

The most formal and traditional invitations are printed on the first page of a double sheet of heavy paper, usually 5 ½ by 7 ½ inches when folded, or on a single sheet of 5 ½ by 7 ½-inch heavy-weight paper. Formal invitations are printed on ivory, cream, or white paper using a shaded or antique Roman typeface. Third-person wording is the rule for formal invitations. Engraving is the most traditional printing style, but

today, both letterpress and thermography are acceptable and popular options as well.

✳ What should be included in a wedding invitation?

A wedding invitation gives guests critical information: Who is hosting the event (traditionally the parents of the bride), the purpose of the event (a marriage), who is being honored (the names of the bride and groom), when the event will take place (the date and time), and where the event will take place (a house of worship or other location). If everyone invited to the wedding is also invited to the reception, then the reception information may be included as well, along with an RSVP, or request for a reply. The style of the invitation indicates whether the event is formal, semi-formal, or casual, and generally sets the tone for the event to come.

❊ What's the traditional wording for a wedding invitation?

The traditional wording for a wedding given by the bride's parents is:

Mr. and Mrs. James Stuart Flynn
request the honour of your presence
at the marriage of their daughter
Elizabeth Anne
to
Mr. Kevin Anthony Murphy
Saturday, the twelfth of June
two thousand eight
at half after four o'clock
St. Mary's Church
Briarcliff Manor, New York

❊ What are the rules for writing a formal invitation?

Long-standing tradition dictates the wording and spelling conventions of a formal invitation. Some specific rules for *formal* wedding invitations follow:

- When a wedding is in a house of worship, or is a religious ceremony performed in another location, the

phrase "the honour of your presence" is used. Note the traditional British spelling of "honour" with a *u*. The same traditional spelling is used for the word "favour" in "The favour of a reply is requested."

- The invitation to a reception or a purely civil ceremony reads: "Mr. and Mrs. John Stuart Flynn request the pleasure of your company . . ."

- When a Roman Catholic Mass is part of the wedding ceremony, invitations may include "and your participation in the offering of the Nuptial Mass" below the groom's name.

- No punctuation is used except for the abbreviations Mr., Mrs., Ms., Jr., or Sr., or when phrases requiring separation occur on the same line, as in the date.

- Numbers in the date are spelled out, as in "the twenty-seventh of August," but long numbers in the street address are written as numerals: "1407 Kensington Drive."

- Half hours are written as "half after four o'clock," not as "half past four," "4:30," or as "four-thirty."

- Mr., Mrs., and Ms., are abbreviated; Jr. and Sr. are preferably abbreviated; but Doctor isn't abbrevi-

ated unless the name is a particularly long one and wouldn't fit on one line. (When addressing the envelope to a guest who is a doctor, it's correct to abbreviate the title.)

- If the invitation includes the handwritten name of the recipient, the full name must be written out. Using a middle initial—"Mr. and Mrs. Scott E. Jenkins"—isn't correct. Using the middle name is optional and can be omitted if length is a factor.

- The invitation to the wedding ceremony alone doesn't include an RSVP, as in the example above.

- On the reception invitation or an invitation that includes both the wedding and the reception, "RSVP," "R.S.V.P.," "R.s.v.p.," and "The favour of a reply is requested" are all equally correct. If the reply is to be sent to an address that's different from the return address on the invitation's envelope, use "Kindly send reply to" followed by the correct address.

- The RSVP and following lines are flush left, not centered.

- Traditionally, the date on formal invitations didn't include the year, but today it's correct to include it,

spelled out: "two thousand nine." The year is always included on a wedding announcement.

- The bride is listed without title or surname unless her last name is different from the hosts'.

- Use the full names of those extending the invitation. If that makes the name too long for one line, omit the middle name but don't use an initial.

- The groom's full name and title is listed.

- The word "to" connecting the bride's name to the groom's is replaced by "and" for invitations to a Jewish wedding.

✳ Should the style of the invitation match the formality of the wedding?

Yes; all elements of your wedding should be consistent. Your invitations set the tone for what guests should expect. A formal engraved invitation for an evening wedding indicates formal dress. Handmade paper imbedded with wildflower seeds would be perfect for an informal afternoon wedding in the country.

✳ **All of our wedding guests are being invited to the reception. Do we need separate invitations?**

No, you can add the reception information after the wording for the wedding invitation. Don't forget to add a request to reply (RSVP) and a reply address if it's not the same as the address on the outer envelope.

Doctor and Mrs. Kenneth McGuigan
request the honour of your presence
at the marriage of their daughter
Jeanne Marie
to
Mr. Stephen Dempsey, Jr.
Saturday, the ninth of April
two thousand nine
at half after five o'clock
Church of the Resurrection
Evanston
and afterward at the reception
Lake Michigan Shore Club

RSVP [The favour of a reply is requested]
23 Soundview Avenue
River Forest, Illinois 60601

❋ We're having a private wedding ceremony with only immediate family present, but we'd still like to have a reception for family and friends. How do we invite our guests?

If you're inviting a few friends and family to the ceremony, the nicest way is to extend the invitation in person or by a short personal note, which can be included with your reception invitation:

> *Dear Aunt Mary and Uncle Jim,*
>
> *Jeff and I will be married on Saturday, June 24th at Trinity Methodist Church in Shelburne. It would mean the world to us if you could be there with us.*
>
> *Love,*
>
> *Deirdre*

Use the following wording on the invitation to the reception:

Mr. and Mrs. Douglas Charles Campbell
request the pleasure of your company
at the wedding reception
for their daughter
Deirdre Mary
and
Mr. Jeffrey Keller
Saturday, the twenty-fourth of June
two thousand ten
at seven o'clock
Lake Champlain Yacht Club
Shelburne

RSVP

Note the wording "the pleasure of your company" is used because this isn't an invitation to a religious ceremony.

✽ Our guest list for the ceremony is larger than for the reception. Do we need a separate invitation to the reception?

Yes, enclose a separate reception card with the wedding invitations for those being invited to the wedding and the reception. The usual wording is:

Reception
immediately following the ceremony
Knolls Country Club
Lake Forest

The favour of a reply is requested
239 Lakeside Drive, Lake Forest, Illinois, 61300

❋ **My fiancé and I would like to send our own invitations. How do we word them?**

You have several options, depending on how formal you want to be. The most formal uses titles and is worded:

The honour of your presence
is requested
at the marriage of
Miss Andrea Jane Brigante
to
Mr. Robert Holden White
Saturday, the tenth of July
two thousand eleven
at half after four o'clock
First Congregational Church
Richmond, Virginia

· · · · · · · · · ·

Or

Miss Andrea Jane Brigante

and

Mr. Robert Holden White

request the honour of your presence

at their marriage . . .

If you wish to be less formal:

Andrea Brigante and Robert White

invite you to attend

their marriage

on

Saturday, July the tenth

two thousand eleven

at half after four o'clock

First Congregational Church

Richmond, Virginia

A reception on the grounds will follow the ceremony

RSVP

Ms. Andrea Brigante

87 Grace Street

Richmond, Virginia 23223

Mature couples or couples who've been living together may prefer to send the invitations in their own names and not use social titles:

> *Andrea Jane Brigante*
> *and*
> *Robert Holden White*
> *invite you to share*
> *the joy of their marriage*
> *Saturday, the tenth of July*
> *two thousand eleven*
> *at half after four o'clock*
> *First Congregational Church*
> *Richmond, Virginia*

❋ **My fiancé and I find traditional wedding invitations too formal for our tastes. Can we write our own invitations? If so, can you suggest the wording?**

Your invitation choices are endless: Paper color, design motifs, typefaces, ink color, borders, and envelope linings—the sky's the limit and stationery stores cater to every taste. You don't have to use the formality of the third-person invitation, and you can be as original as you wish as long as the invitations

are dignified and sincerely reflect your sentiments. Here's an example of a simple invitation:

Elizabeth Gates and Michael Hong
invite you to celebrate
their marriage
on
Saturday, June the 5th
at four o'clock
2 Fox Run
Lander, Wyoming

✳ **My parents are hosting the wedding, but my fiancé's parents want to be on the invitation as well, even though they're not contributing to the ceremony or the reception. What should I do?**

There are several reasons to include the groom's parents on the invitation. If the groom's parents are contributing to the wedding financially or are contributing their time and effort to assist the bride and her family, then it's fair and respectful to include their names on the invitation.

There's another very good reason to include the groom's family in the invitation, which goes beyond the traditional

emphasis on the hosts' financial contribution and is based on the underlying principles of etiquette: consideration and respect. Including both families in the invitation is a way for the bride and groom each to honor their parents, the people who have literally brought the two of them to their wedding day. Talk to your parents and see if any of these options will work for you.

Both parents are listed by their full names and titles, brides' parents first:

Mr. and Mrs. Joshua Zimmerli
and
Captain and Mrs. Aaron Schwartz
request the honour of your presence
at the marriage of
Cynthia Ann Zimmerli
and
Mr. Daniel Isaac Schwartz

Or you could add "son of" after the groom's name:

Mr. and Mrs. Joshua Zimmerli
request the honour of your presence
at the marriage of their daughter
Cynthia Ann Zimmerli
and
Mr. Daniel Isaac Schwartz
son of
Captain and Mrs. Aaron Schwartz

A third option is the form followed in countries that use a double invitation with the bride's family's invitation on the right and the groom's family's invitation on the left:

Mr. and Mrs. Joshua Zimmerli	*Captain and Mrs. Aaron Schwartz*
request the honour of your presence	*request the honour of your presence*
at the marriage of their daughter	*at the marriage of their son*
Cynthia Ann	*David Isaac*
and	*and*
Mr. Daniel Isaac Schwartz	*Miss [Ms.] Cynthia Ann Zimmerli*

❋ **My partner and I are planning our same-sex union. Who issues the invitations, and what do we call the ceremony?**

In general, the same invitation rules apply for same-sex unions as for other wedding invitations. Some gay and lesbian couples use the terms marriage or wedding. Depending on your feelings and the type of ceremony you're planning, you could call it a commitment ceremony, affirmation ceremony, celebration of commitment, rite of blessing, blessing of the union, relationship covenant, partnership covenant, or union ceremony. You and your partner should choose what best describes your ceremony so your guests know what to expect. The invitations may be issued by yourselves, or by one or both sets of your parents. If the ceremony is performed by clergy or is in a house of worship, use the phrase, "the honour of your presence." If it's a civil ceremony, use "the pleasure of your company." The only other decision to make is whose name will come first on the invitation—a decision for you and your partner.

> *The honour of your presence*
> *is requested*
> *at the marriage of*
> *Susan Beth Gibson*
> *and*
> *Georgia Lee O'Dell*

Or

Mr. and Mrs. Franklin Johnson
Mr. and Mrs. Jason Bolivia
request the pleasure of your company
at the civil union of their sons
Victor Kenneth Johnson
and
Marc William Bolivia

❋ **How is a wedding invitation worded when . . .**

. . . the groom's family gives the wedding?

Mr. and Mrs. Antonio Diaz
request the honour of your presence
at the marriage of
Miss [Ms.] Latoya Kenisha Armond
to
their son
Carlos Delapaz Diaz . . .

. . . the bride has only one living parent?

When either the bride's mother or father is deceased, then the invitation is issued only in the name of the living parent:

Mr. [Mrs.] Arthur Watson Driscoll
requests the honour of your presence
at the marriage of his [her] daughter
Susan Patricia
to
Mr. Drew Randolph Morris . . .

There are times when a bride would really like to include the name of the deceased parent. This is fine, as long as the invitation doesn't appear to be issued by the deceased, as in ". . . the late William Tierney requests the honour of your presence . . ." Here's a good way around that awkward wording:

Dianne June Tierney
daughter of Ann Tierney and the late William Tierney
and
Drew Randolph Morris
request the honour of your presence
at their marriage . . .

... the bride has no living parents?

In this case, a relative, such as a sibling, grandparents, or an aunt and uncle, hosts the wedding. The invitation wording expresses the bride's relationship to her relative:

> *... at the marriage of his sister*
> *Mary Ann*
> *to ...*

Or

> *... at the marriage of their niece*
> *Miss [Ms.] Mary Ann Cole*
> *to ...*

Note that a title precedes the bride's name, since her last name is not the same as the hosts'.

...the bride has a stepfather?

If the bride's mother has been widowed or divorced and re-married, and she and her husband are hosting the wedding, the invitation reads:

Mr. and Mrs. Bruce Denoyer
request the honour of your presence
at the marriage of her daughter [Mrs. Denoyer's daughter]
Francine Anne Colby . . .

If the bride's own father had no part in her life and her step-father has brought her up (legally adopted or not), then the phrase "at the marriage of their daughter" is used.

...the bride's mother and father are divorced and only her mother is giving the wedding?

When the bride's mother is giving the wedding, the invitation is issued in her name:

Mrs. [Ms.] Virginia Allen Barnes
requests the honour of your presence
at the marriage of her daughter
Lola Allen . . .

... the bride's divorced and remarried parents are giving the wedding together?

In the event that relations between the bride's divorced parents (one or both of whom may have remarried) are so friendly that they share the wedding expenses and act as co-hosts, both sets of names appear on the invitation. The bride's mother's name (and her spouse's) goes first:

Mr. and Mrs. Shelby Goldring
and
Mr. and Mrs. Michael Levy
request the honour of your presence
at the marriage of their daughter
Rachel Lynn Levy ...

... the bride is a young widow or divorcée and marrying for the second time?

Today, whether widowed or divorced, couples usually issue invitations to a second wedding themselves. It's also fine for parents to issue the invitation, using the same wording as the invitations to a first wedding. The only difference is that if the bride kept her married name, it should be used:

Doctor Elizabeth and Mr. Daniel Thomas McCann
request the honour of your presence
at the marriage of their daughter
Sheila McCann O'Neil . . .

. . . the groom is in the military?

If the groom is a member of the armed services or is on active duty in the reserve services, then he may use his military rank or rating. Check with a local office or the protocol office of the service branch for the correct usage of ranks. If the groom is in another nation's military, check with their Washington, D.C. embassy for the correct usage.

For officers whose rank is captain or higher in the Army, Air Force, and Marines, or lieutenant, senior grade or higher in the Navy, the rank appears on the same line as the name, with the service branch below:

Captain Arthur O'Malley
United States Army

For junior personnel, the rank and branch of service are printed below their names:

Samuel Todd Holmes
Ensign, United States Navy

Or

Neil Proctor Armstrong
Staff Sergeant, United States Air Force

In the Army, first and second lieutenants use "Lieutenant," but in the Air Force and the Marines, "First Lieutenant" and "Second Lieutenant" are correct.

Some military personnel, if they prefer, may use their titles (chaplain, Doctor) instead of rank or rating on social invitations with no indication of service branch:

Doctor Michael Martin Briggs

For reserve personnel on active duty *only,* follow the same rules regarding titles (rank or rating) but add "Reserve" to the second line: United States Army Reserve, United States Naval Reserve, or United States Air Force Reserve.

Retired officers of the regular armed forces may retain their titles, depending on their particular service branch regulations. A single, divorced, or widowed retired officer's name appears with his service branch and "Retired":

General Clarence Rodriguez
United States Air Force, Retired

... the bride is in the military?

When the bride is on active duty, both her rank or rating and the branch of the military are included in the invitation. The bride's first and middle name appear on one line with her rank or rating and the branch of the military on a separate line:

marriage of their daughter
Marie Claire
Lieutenant, United States Army

... one or both of the hosting parents is in the military?

When a parent is a member of the armed forces, either on active duty, a retired officer, or retired after many years of service, the military rank or rating may be used:

General and Mrs. Herman Wright
request the honour of your presence

Don't add the service branch or "Retired" since a civilian spouse cannot be included in a military designation. Those retired may prefer to use their civilian titles:

Mr. and Mrs. Herman Wright

If both parents are in the military, the one with the higher rank is listed first:

Commander George Nichols and Major Brenda Nichols

Or

Commander and Mrs. George Nichols

If the mother is in the military and the father is a civilian:

Colonel Martha McGee and Mr. Jerome McGee

✳ **I'm a medical doctor and my fiancé has a PhD. Do we use our titles on our wedding invitation?**

Normally, a woman's title isn't used on an invitation. For example, if your parents are hosting, the invitation reads:

at the marriage of their daughter
Carmen Estelle

Your fiancé wouldn't put PhD after his name—academic designations aren't used socially—but if he's *always* referred to as "Dr." then it's fine to use that title. If you're issuing the invitation yourselves and you're using titles, then you may also use the title "Doctor":

> *Doctor Carmen Estelle Santiago*
> *and*
> *Doctor James Henry Nuñoz*
> *request the honour of your presence . . .*

❋ My fiancé will receive his medical degree in June and we're getting married in July. Even though he won't officially be a doctor at the time that we order the invitations, should we include his title on the invitations?

Sure, since he will officially be an MD when the wedding takes place. You wouldn't use his title if you marry before he graduates.

✳ My sister and I are planning a double wedding. How do we word the invitation?

This is a time when the older sister gets to pull rank, so to speak. Her name goes first:

Mr. and Mrs. Mitchell Trent Raines
request the honour of your presence
at the marriage of their daughters
Cynthia Gale
to
Mr. Peter Allen Bodow
and
Mary Lynn
to
Mr. Angelo Ramirez

✳ Our wedding will be held at a friend's home. Are the invitations issued in their name or in my parents' name?

How lovely! Even though your friends have been kind enough to offer their house for the wedding, the invitation is still issued in your parents' name. The line for the place where the wedding takes place reads:

at the residence of Mr. and Mrs. Henry Mills Colter
Claremont, New Hampshire

✳ **My husband and I married in Europe three months ago and have just returned home. My parents have graciously offered to give a wedding reception for us. How are the invitations worded?**

Invitations to belated receptions are often the case for destination weddings:

Mr. and Mrs. Reid Twitchell
request the pleasure of your company
at a reception
in honor of
Mr. and Mrs. Christopher Miller . . .

If you want to be less formal, say:

Please join us for a reception
in honor of Marcy and Chris . . .

✳ **Both of our parents are divorced and remarried and my fiancé's stepmom uses her maiden name. My dad is a doctor. Do we abbreviate "Doctor"? We want to have traditional, formal invitations. How do we list everyone, including their new spouses?**

Increasingly, the groom's parents share in hosting the wedding and it's not unusual for divorced parents to co-host.

Let's start with the general theory, and then cover all the particulars. For a cohosted wedding, the bride's parents are listed first, then the groom's. In the case of divorce, the mothers' names precede the fathers'. "Ms." is the correct title for a woman using her maiden name, and "Doctor" should be written out, not abbreviated:

Mr. and Mrs. James Allen Morrison (mother of the bride and spouse)
Doctor and Mrs. Henry Sabin Kent (father of the bride and spouse)
Ms. Amy Bennet and Mr. Arthur Cohen (mother of the groom and spouse)
Mr. and Mrs. Brent Watling Anderson (father of the groom and spouse)
request the honour of your presence
at the marriage of [their children]
Catherine Miles Kent (the bride should use her last name for clarity)
and
Mr. Alex Watling Anderson

If the families wish to, the words "their children" may be added after the phrase "at the marriage of."

✽ We're only inviting twenty people to our wedding. Do I have to purchase printed invitations?

The loveliest and most flattering wedding invitation is the handwritten, personal note. Obviously impractical for even a medium-sized wedding, it's the perfect choice for a small wedding.

✽ Why are tissues included in wedding invitations?

Engravers used tissue sheets between each printed piece to protect against ink smudges or blots while the ink slowly dried. Today, improved technology has made tissues unnecessary. People continue to use them as a bow to tradition, but it's perfectly fine to omit the tissues if you wish.

✽ Do you recommend using response cards?

Yes, because it will make keeping track of your guest list much easier. Formerly, a handwritten reply was the only proper response to a wedding invitation, and response cards were considered in less than the best of taste. Well, practicality rules the day now, and it's preferable to send a response card than spend hours trying to track down clueless guests.

The response card is inserted with the invitation and is engraved or printed in the same style and card stock as the invitation. Most people pre-address and stamp the reply envelope as well. This makes it easy for guests to send their answer.

M_____

will _____ *attend*

Or

*accepts*_____

*regrets*_____

The favour of a reply is requested by July 26.

The "M" precedes the space where the guest(s) write their name(s) and the name of a guest, if they were invited to bring one:

Mr. and Mrs. James Bailey

❋ **Wouldn't it be easier to add "number of persons" to the reply card?**

Actually, that's not a good idea. The names on the outer or inner envelope indicate exactly who's invited. That means

that other family members whose names aren't on the envelope aren't invited. When "number of persons" is on the reply card, recipients may be confused and fill in the number of persons in the household. This results in too many guests, or in embarrassing conversations and possibly hurt feelings.

✳ **We're offering a menu choice at the reception. Is it okay to include these options on the response card?**

You can, but generally, the choice of entrée isn't included on the response card. It means more record keeping for you, and it doesn't always help the caterer, either, as some guests won't remember what they chose. It's better to serve one meal, or if you have two entrées, let your guests choose when they are being served.

✳ **We're planning a really formal wedding. Even though the reception is after six in the evening, I'm concerned that our guests won't know to wear formal clothes. Can I put "Black Tie" on the invitation?**

It's incorrect to put "Black Tie" or to specify any other dress code on the invitation to the ceremony. If it seems really important to include this instruction, then it's only added to the invitation to the reception and it's placed in the lower right-hand corner.

✻ How do I tell invitees that their children aren't included?

You shouldn't do this by writing "adults only" or "no children" on the invitation. Be very clear to address the invitation only to those you're inviting. Have your hosts and attendants primed to help you out by spreading the word, if asked. And, of course, if someone calls indicating that they're bringing little Johnny or asking if they can bring him, you can kindly and directly say that space is limited and you don't have room for extra guests.

✻ What's an at-home card?

This little card, usually smaller than the reception card and included with the invitation, is a way for the bride and groom to let their friends know their new address and a great way for the bride to let people know if she'll be taking her husband's name. Even though they won't be married when the card is sent, it's fine to use their married name:

Mr. and Mrs. Bryan Ostereich [Franca Van Vleck and
Bryan Ostereich]
will be at home [at home]
after July second
342 Sycamore Lane
Hopewell, New Jersey 06525
(908) 555-4321

These cards are also useful for guests who send a gift after the wedding.

✳ Should I use one envelope or two for my wedding invitations?

The traditional formal invitation is sent in two envelopes: an outer envelope that's addressed to your guest(s) and stamped, and an inner envelope (containing the invitation, reception card, reply card, and other material) that bears the names of the specific people invited. Although it may seem complicated or too formal, it's actually very practical because it lets the hosts be very clear about who's invited: other family members, children, and whether or not an invited guest may bring a guest.

But if this kind of communication doesn't fit your circumstances or guest list, it's perfectly fine to omit the inner envelope.

✳ When there are two envelopes, how are they addressed?

The outer envelope is addressed with the names and address of the person(s) invited: "Mr. and Mrs. John Smith" and the inner envelope is addressed to "Mr. and Mrs. Smith" without first names or address. Now suppose that you'd like your friend Mischka to bring a guest. The outer envelope is addressed to "Ms. Mischka Kouriakin" and the inner envelope

is addressed to "Ms. Kouriakin and Guest." If you don't want Mischka to bring a guest, then only write Ms. Kouriakin on the inner envelope. Now it's really clear that she's the only one invited. On the inner envelope, it's fine to write the names of intimate relatives or life-long friends in informal and familial terms, like Grandmother, Aunt Mary and Uncle Joe, or Cammie and Henry.

❋ **I'm not using two envelopes. How do I let my guest know he may bring a date?**

Since you don't write "and Guest" on the outer envelope, include a note or give your guest a call to let him know he may bring a "plus one."

❋ **We want to send out "save the date" cards. Does everyone who receives a save the date card have to get an invitation?**

Yes, they do. But it's also true that not everyone who receives an invitation has to receive a "save the date" card. Now's the time to take a good look at your guest list and only send "save the date" cards to the closest friends and family on your list, the ones who are the core of your guest list. Your other guests can just receive an invitation. This way, you haven't committed yourself to any but your most important guests.

✳ **I have all my guest information stored in a database. It can save me a lot of time and money if I print out labels for my invitations. Is this a good idea?**

Even though they may seem to be a time and money saver, stick-on labels are much too impersonal. Instead, plan ahead and take the time to handwrite every envelope, so that it's in keeping with the personal nature of a wedding. If you can't afford to hire a calligrapher, perhaps your mom or your maid of honor and attendants can help.

✳ **Are abbreviations used when addressing wedding invitation envelopes?**

Only titles such as Mr., Ms., Mrs., Dr., or Rev., are abbreviated. You don't have to use middle names, but if you do, they're written out in full and an initial isn't used.

In the address lines, words like "Street," "Avenue," and "Boulevard" are also fully written out. In the past, the name of the state was also written out, but nowadays the postal service prefers the two-letter state abbreviation with no comma between the city and the state. It's fine to use that form if you wish.

✳ **How do you address an envelope when a woman is a doctor, or both the husband and wife are doctors?**

If the woman uses her husband's name socially, the address is "Dr. Barbara and Mr. James Werner." If she uses her maiden name both professionally and socially, it's "Dr. Barbara Hanson and Mr. James Werner." Note that her name comes first because her professional title "outranks" his social title. If both husband and wife are doctors and use the same last name, it's either "The Drs. Werner" or "Drs. Barbara and Robert Werner"—either first name can go first. The same format is used if the woman is a reverend or if both she and her husband are reverends.

✳ **When is a wedding invitation addressed to Mr. and Mrs. John Smith and Family?**

Only when you're including *all* of the Smith family living under one roof: Mom, Dad, and all the young children. Be careful: Mr. and Mrs. Smith may assume you mean the extended Smith family: Grandma and Grandpa Smith, as well as numerous Smith cousins who live around the corner. So that there are no misunderstandings, address the inner envelope to the individual Smiths whom you'd actually like to invite:

Mr. and Mrs. Smith
Christine, Catherine, and Robert

❊ At what age do children receive their own invitations?

Children over thirteen years of age should receive their own invitations, if possible. Young sisters and brothers may be sent a joint invitation addressed to "The Misses Jones" or "The Messrs. Jones" on the outer envelope, with "Andy, Doug, and Brian" written on the inner envelope to make it perfectly clear that they're all invited. When there are boys and girls in the family, the outer envelope is addressed:

> *The Messrs. Jones*
> *The Misses Jones*

Or

> *The Messrs. Andrew and Douglas Jones*
> *The Misses Barbara and Sarah Jones*

❊ Should the wedding invitation have a return address on the envelope?

Yes, the U.S. Postal Service requests that all first-class mail have a return address on the upper left-hand corner of the envelope, but it's perfectly acceptable to put it on the back flap. The return address also lets guests know where to send replies and gifts if an RSVP address is not included on the invitation.

✳ I'm trying to figure out how many invitations to order. Do I
send them to ...

...the person who performs the ceremony and his or her spouse?

Yes, it's courteous and considerate and shows you're definitely
including the spouse.

...the fiancé(e) of invited guests?

Yes, the spouse, fiancé(e) or live-in partner of each invited
guest should also be invited, even if you've never met. It's nice
to send someone's fiancé(e) a separate invitation, but if that's
not possible, then include his or her name on the inner enve-
lope below the name of the invited guest.

...the bridal party members?

Yes. They're not really expected to reply, so you don't need to
include a response card, but they may like to have the invita-
tion as a memento.

...the groom's parents?

Yes, it's a courtesy and a special memento for them as well.
Again, it's not necessary to include a response card.

. . . relatives and friends living too far away to attend the wedding?

Here you'll have to make a judgment call. Close friends and relatives may be hurt not to receive an invitation, even if it's clear that they can't make the trip. And, you never know, the opportunity to attend may present itself. But more distant friends or relatives may think you are just "fishing" for a gift if they do receive one! If you think that might be the case, consider sending an announcement, which carries no obligation to send a gift.

. . . small children who aren't invited to the reception?

Tread carefully here. If it would be convenient for the parents to have the children taken home before the reception, then it's fine—otherwise you're setting up an awkward situation.

. . . people in mourning?

Yes, even though they may not attend.

✳ We've changed the date of our wedding. Our invitations have already been printed. Can we cross out the old date and insert the new one?

If there's time, insert a printed card or handwritten note that says "The date of the wedding has been changed from March sixth to April twelfth." If there's no time to have a card printed, then, with a pen, neatly cross out the old date and insert the new one.

If the invitations have already been mailed, then, depending on the time frame, send a printed card or note, or, if the guest list is small or time is of the essence, phone the information. E-mail would also work, but only if you're 100 percent sure all the recipients will get the message.

❊ **We canceled our wedding plans shortly after mailing the invitations. How do we inform people?**

If there's time, then send a printed announcement:

Mr. and Mrs. Roy Kennon
announce that
the marriage of their daughter
Madison Gray
to
Mr. Stephen Markham
will not take place.

This saves both you and your parents from having to answer questions when you're undoubtedly upset. If time is too short to send an announcement, then phone your guests. Have a prepared message, "I'm sorry to tell you that Steve and Madison's wedding has been called off." It's a good idea to have attendants, friends, or relatives make these calls so they can

spare you and your parents from having to explain over and over.

✳ How do announcements differ from invitations? Who gets them and who doesn't?

Announcements are just that: They announce that a wedding has taken place, and are sent after the wedding. It's never mandatory to send them, but they serve a useful purpose: informing old friends who've been out of touch, business associates, people who live too far away to attend, or closer friends and relatives who couldn't be included because the wedding and reception were small. Announcements carry no gift obligation, but some people may wish to send a gift, note, or card. Announcements are not sent to anyone who attended the ceremony and/or the reception because they already know the news.

✳ How is an announcement worded?

The traditional announcement follows the style of the wedding invitation (typeface, paper, printing method) and the envelopes are addressed in the same manner as the invitations. The variations in circumstances, names, and titles follow the rules for wedding invitations except that the year is always included on an announcement. Announcements are sent by the bride's family or the bride's and groom's families:

Mr. and Mrs. James Welch
have the honour of
announcing the marriage of their daughter
Amy Sue
to
Mr. Harrison Scott Furness
Saturday, the twelfth of June
two thousand nine
Sheffield, Vermont

Other variations are "have the honour to announce" or simply "announce."

When both families issue the announcement:

Mr. and Mrs. James Welch
and
Mr. and Mrs. Percy Furness
announce the marriage of
Amy Sue Welch
and
Harrison Scott Furness
Saturday, the twelfth of June
two thousand nine
Sheffield, Vermont

✳ How soon after a wedding are announcements mailed?

Announcements are usually mailed the day after the wedding, but may still be mailed up to several months later.

✳ What information should be included in a newspaper wedding announcement and when should it be sent?

Deadlines and wedding announcement styles differ paper to paper, so call about two months ahead to get the necessary information. Don't forget to ask if you can include a picture. It's a good idea to prepare an electronic document with all the basic information in case you need to submit it to more than one paper or if you can submit the information online, which could be a big time saver. Some papers even have an online wedding section and post photos, too. In general, you provide the following:

- Bride's full name and town of residence

- Bride's parents' names and town of residence

- Brides' parents' occupation(s)

- Bride's maternal and paternal grandparents

- Bride's school and/or college

- Bride's occupation

- Groom's full name and town of residence

- Groom's parents' names and town of residence

- Groom's parents' occupation(s)

- Groom's maternal and paternal grandparents

- Groom's school and/or college

- Groom's occupation

- Date of wedding

- Location of wedding and reception

- Names of bride's attendants and relationship to bride or groom, if any

- Names of groom's attendants and relationship to bride or groom, if any

- Description of bridal gown and bouquet (optional)

- Description of attendants' gowns (optional)

- Name of minister, priest, rabbi, or other officiant(s)

- Name of soloist, if any

- Where couple will honeymoon (optional)

- Where couple will reside (town) after the wedding

- Photograph of the bride or couple

CHAPTER 6

showers and other wedding parties

❋ Who hosts a bridal shower?

Today, while an engaged couple shouldn't throw themselves a shower—a direct "ask" for gifts—it's fine for anyone else to host, including the bride's mother or sister. If the bride is visiting her future in-laws and the groom's mother wants hometown friends and family to meet her, she may host a shower, reception, or engagement party. Sometimes, several of the bride's friends or relatives host the shower together. Individual circumstances guide the decision.

❋ I've heard that bridesmaids are supposed to host a shower for the bride. Is this true?

Despite what you might've heard, the maid or matron of honor and the bridesmaids aren't required to host a shower as part of their official duties. They certainly may host one if they wish, but it's a good idea to have a group discussion and see if everyone has the time and the resources to do so. Nor should any one bridesmaid take it upon herself to organize a shower and then ask the others to share the costs.

❋ Are showers for women only?

Definitely not! While many brides-to-be stick to the all-female tradition, others are including guys as well, with the focus on having a great time with friends. Coed or "Jack and Jill" showers include the groom and his friends.

❋ I'm a bridesmaid in a good friend's wedding. I've been invited to several showers, but I don't think I can afford a gift for each one. What do I do?

Relax. You only need to bring a gift to one shower, even if you attend the others. If you're uncomfortable about arriving "empty handed," bring a card, or a small token of your affection: note cards, a framed photo of you and the bride, guest soaps, or a

little vase with a nosegay. You could even put together "no cost" gifts, such as a dozen of your favorite recipes, or the offer of a manicure or an afternoon of "bride's errands."

❋ How many showers may a bride have?

There's no specific rule here, but common sense and consideration should guide you. Multiple showers are fine, but be sure to invite different guests to each party.

❋ Who's invited to a wedding shower?

Wedding showers are intimate affairs. While the exact size of the event is up to the host or hostess, the guest list usually includes close friends, family members, and attendants. There's only one rule: Anyone invited to a shower should be invited to the wedding.

❋ If my office mates throw me a shower, must I invite them to the wedding?

Office showers are one of the rare occasions when the rule "anyone invited to the shower should also be invited to the wedding" doesn't apply. Just make sure that your office mates know that you aren't able to invite them all.

✳ **I'm being married for the second time. May my matron of honor have a shower for me?**

Sure, but keep the guest list to close friends and family.

✳ **I don't want to open gifts at my shower because I think it's boring for people to watch you open gift after gift. My mom thinks people will be upset if I don't open the gifts. What should I do?**

Your mom is right. Your friends are showering you with gifts, and opening the gifts and expressing thanks is the highlight of the celebration. Choosing not to open the gifts would disappoint those who made the effort to select, purchase, and wrap something just for you. However, the gift opening doesn't have to happen all at once, with everyone sitting in a circle. You could break up the present opening into several stages, perhaps before and after refreshments. If you really don't want to open the gifts at all, then let it be known that a gift-free event, such as a cocktail gathering or a bridal luncheon, would be preferable.

✳ **Is it true that the bride doesn't have to send a thank-you note for a shower gift if she opens it in front of the giver and thanks her in person?**

In the past, when showers—and the gifts—were less elaborate and the attendees were her most intimate friends and family,

the bride didn't need to send a note if she thanked the giver in person. But today a handwritten note is a "must-do" to acknowledge a guest's generosity. People really will appreciate your thoughtfulness. Send the notes as soon as possible, preferably within two weeks after the shower. The groom can help, too, if it was a coed shower.

✳ **I keep reading about bachelorette parties. I thought guys had bachelor parties and girls had a bridal luncheon?**

Well, the girls can still have the bridal luncheon, but a bachelorette party is the bride's last hurrah, the ultimate "girls' night out." That doesn't mean it has to be a weekend in Las Vegas—although that option tops the list for many! These days the bride and her best mates plan everything from dinner at an elegant restaurant to a spa getaway or a weekend at the beach. The idea is to have some quality time together.

✳ **Help! I'm a maid of honor and the bride is insisting that the bridesmaids treat her to a long weekend at a fancy hotel in Las Vegas. Most of us can't afford to do this. What do we do?**

The bachelorette party has become so popular that many brides think it's now a "must-do." It's not. Being an attendant can be costly. You're responsible for purchasing your clothing, paying for your transportation to and from the wedding,

contributing to a bridesmaids' gift for the bride, purchasing a shower gift if there's a shower, and purchasing or contributing to a gift for the couple. For many attendants, that's stretching the budget already. There's no requirement for you to host a shower or a bachelorette party as well.

It's time for you and the other bridesmaids to have a real heart-to-heart with the bride and explain the circumstances. As much as you'd like to grant her wish, you all just can't afford it. Be kind but firm. Try to find out what she really wants to get out of the weekend—time with friends, a wild night at a bar, the chance to stay at a terrific hotel—and see if it can happen another, less costly way.

✳ What is the bridesmaids' luncheon?

Traditionally, this was the girl version of the bachelor party—a time for all the bridesmaids to have a last get-together with the bride before the big day. It can be hosted by the brides-maids, or by a close friend or relative of the bride. Or the bride and/or her mother could host the party for the bridesmaids. Often the bride's mother and grandmothers are invited. It's a lovely time for the bride and bridesmaids to exchange their gifts for one another.

❋ What is a bachelor dinner?

This is the groom's last hurrah with his groomsmen, ushers, and male friends as a single man. It may be hosted by the groom, by the groomsmen, or by a group of friends. The traditional party is an elegant dinner, topped off by a toast by the groom about his bride. Today, camping trips, a sporting event, or group adventure are popular alternatives.

❋ We have out-of-town guests who will be arriving the day before our wedding and staying until the day after. Should we plan on entertaining them? Do we pay for their accommodations? What are our obligations?

It's wonderful when faraway friends and relatives are able to attend your wedding. When these guests accept your invitation to the wedding, they aren't expecting you to entertain them for an entire weekend, nor are you expected to pay for their lodging. Some may be looking forward to a mini vacation and will want to take advantage of what your area has to offer on their own. Provide out of towners with a list of local accommodations, attractions, and restaurants. You can enclose this information with the invitation, mail it separately as guests accept, or leave it where they are staying as a welcome package.

Sometimes local friends will offer to host a barbecue, cocktail party, or post-wedding brunch. Make sure that you provide these hosts with a list of guests so that they can extend invitations, and be sure to thank them with a note and a gift.

✳ When is the wedding rehearsal held? Who takes part in the rehearsal?

Usually, the wedding rehearsal is held the afternoon or evening before the wedding, or at a time that works for the officiant and the venue. This is the official "run-through" of the processions and the ceremony, so the bride, the groom, all the members of the wedding party, and the bride's parents need to be there to practice their parts. Since the groom's parents don't have an "official" role in the wedding, they can choose to attend or not.

✳ What is the rehearsal dinner and who hosts it?

The groom's parents usually host the rehearsal dinner which, traditionally, is held the night before the wedding, after the wedding rehearsal. It's an opportunity for the two families to come together and get to know each other. In terms of style, it shouldn't be more formal than the wedding reception. It's the first social event that brings the entire wedding party together and the chance for the groom's family to entertain. It isn't nec-

essary to have a rehearsal dinner, and if a couple doesn't wish to have one, their choice should be respected. That said, it's a rare wedding that doesn't have some sort of dinner for close friends or family the night before. If the groom's parents are unable to host the dinner, it may be hosted by the parents of the bride, relatives, close friends, or by the bride and groom themselves.

✳ My fiancé's parents are from out of town. How can I help them arrange the rehearsal dinner?

It's very thoughtful to provide your fiancé's parents with a list of local restaurants, clubs, or hotels that would be an appropriate place to host the dinner, preferably near to the rehearsal. Make sure that you let them know the time and date of the rehearsal and approximately how long it will take—your officiant will be able to give you a good estimate. Provide them with the mailing addresses of the guests they wish to invite, and let them know the style and formality of your wedding reception. You can also offer to help with local details. But remember, ultimately it's their party.

✳ Who's invited to the rehearsal dinner?

The basic rehearsal dinner guest list includes: the bride, the groom, their parents, grandparents, siblings, members of the wedding party, and the officiant and his or her spouse. Step-parents and their spouses should also be invited, as well as any spouse, fiancé(e), or live-in companion of any member of the wedding party. It's also kind to include an attendant's guest who's also invited to the wedding, but it's not required.

Include the bride's and groom's children from a previous marriage unless they're too young. The same applies to junior ushers, junior bridesmaids, flower girls, and ring bearers. Consider the hour and formality of the event (and their duties the next day) when making a decision, and again, depending on their ages, you may need to invite their parents as well.

After that, the hosts can invite any number of people, but the dinner shouldn't rival the reception. Some typical additions

are godparents, aunts and uncles, nephews and nieces, cousins, and close friends.

✳ My fiancée's parents think that we should include all of the out-of-town guests at the rehearsal dinner. Is this true?

In a nutshell: No, you're not obligated to include out-of-town guests at the rehearsal dinner, and most guests know that they're on their own except for the wedding. Alternatives for out-of-town guests include providing a list of local restaurants or arranging for friends to host a dinner, barbecue, or cocktail party.

✳ Are gifts given at the rehearsal dinner?

There is no gift obligation associated with a rehearsal dinner. However, this may be a good time for the couple and their attendants to exchange gifts, as well as any gifts the couple and their family members may be planning to exchange.

✳ Who makes toasts at the rehearsal dinner?

Toasting is a traditional part of the rehearsal dinner and usually takes place during dinner or dessert. The host—usually the groom's father—makes the first toast, welcoming the guests and expressing his pleasure at the upcoming marriage. Then the bride's father makes a return toast, followed by toasts from attendants and anyone else who wishes to give one. The bride

and groom may also stand and speak about each other, and they end by toasting first their respective parents, and then their friends and relatives.

❋ Are there any rules to seating people at the rehearsal dinner?

There are so many configurations that it's best just to give a few guidelines. The hosts should head the main table. The bride and groom should be seated together, usually flanked by the best man and the maid or matron of honor. More to the point, if you're seating guests at more than one table, try to find a congenial mix. After all, this dinner lets both families and the attendants get to know each other a little better. Whether you mix old and young, his family and hers, there is one danger point to keep in mind: Ex-spouses should never be seated at the same table.

❋ Many guests will be staying over after the wedding. We'd like to have a brunch for them the next morning. Who hosts this event?

A brunch the morning after the wedding is a wonderful way for guests to get together one last time to enjoy each other's company— as well as a little refreshment before heading home. Although not a requirement by any means, they've become very popular. Traditionally, the brunch is hosted by the parents of the bride, either at

their home, at a restaurant, or in a private room in a club or hotel. There's no rule here and anyone may host a brunch. A close friend or relative of the bride's family may offer to host the brunch in their home as a wedding gift to the couple. Alternatively, a group may host—such as parents of the bride and groom, the attendants, friends of the couple, or any combination thereof—allowing the various hosts to split the costs and responsibilities.

✳ Who's invited to a post-wedding brunch?

You can invite all your wedding guests, if you wish. Does this mean that the brunch will be as big as the wedding reception? Probably not. Usually just those who are spending the night or who live right in town will attend. Another approach is to limit the guest list to the wedding party, immediate relatives, and any out-of-town guests who stayed overnight. This is sometimes the perfect answer to the "how do I entertain out-of-town guests?" dilemma.

✳ We're having a small destination wedding, but would like to have a reception when we return home. Is this okay?

It's fine for you or your parents to hold a belated reception to celebrate your marriage. This event can be as formal or informal as you or your hosts wish to make it. Possibilities include a casual cocktail buffet or barbecue, or it can mirror an actual

wedding reception, right down to the cutting of the cake and the bride wearing her wedding dress. The one way in which a belated reception always differs from the real thing is that wedding gifts are not expected, although close friends and relatives are certainly free to give gifts if they choose.

❈ What is a second reception?

A second reception is just that, reception number two. If the couple had a full-blown reception after their wedding but got married in a place that prevented a number of family members or friends from attending—for instance, if the wedding was held in the bride's hometown in New York but the groom's family all live in Hawaii—then the couple or their family may choose to have a second celebration in a place convenient for those who didn't attend the actual wedding. The second reception is usually on the less formal side—a cocktail party, brunch, buffet dinner, or barbecue. Attendance by members of the wedding party is purely optional, as are gifts.

wedding gifts and thank~yous

※ **We'd like to set up a bridal registry. Is this okay?**

The bridal registry is a wonderful tradition that helps guests know what you would like and need. In addition to the traditional china, flatware, and linens, couples can register with stores specializing in items including hardware, garden supplies, or sporting goods. Couples may already have acquired significant household items, especially if it's a second wedding, in which case alternative registries such as charity registries or honeymoon registries are popular options.

※ **Are there some guidelines for setting up a registry?**

Here are a few things to keep in mind:

- Remember, it's always up to the guest to choose your gift, whether it's on the registry or not.

- Register for items in a variety of price ranges to accommodate guests' varied budgets.

- Don't register for the same items at two different stores or Web sites. That can easily lead to duplicate gifts.

- Consider registering at national chain and/or catalog stores. This will make it easier for out-of-town guests.

- Set up your registry early so that guests attending showers also have an opportunity to consult the list for ideas.

❋ **Should I register alone, or should my fiancé go with me?**

This is definitely something you'll want to do together. First of all, it's fun, and retailers have made it easy. Most stores have checklists that contain every conceivable item you could possibly want. You may not need it all, but these lists can remind you of key items. Decide if your combined taste is modern or traditional; what flatware you prefer; or which china goes

with your décor. And yes, you'll probably need to compromise. You might think of things that will outfit the bath, but he'll remember the grill tools.

✳ How do we let people know where we're registered?

Above all, share this information respectfully. The tried and true method is word of mouth. Once you've registered, provide your parents, attendants, and those close to you with a list of your registry sources, their addresses, and how to contact them by phone and/or the Internet. Most people know to ask a couple's families and close friends for this information. If you're asked directly, you can say something like, "Whatever you choose would be special. You can find our registries at XYZ and Such and Such stores if you'd like. Thanks for thinking of us."

✳ Is it okay to put registry links or registry information on our wedding Web site?

It's a great idea to have registry links on your wedding Web site, as long as they're not the first thing a guest sees when visiting the site! Links also have the benefit of allowing guests to shop right from their homes at any time that's convenient for them. It's fine to add a list of brick-and-mortar stores with address and phone number as well.

❋ **We just registered at a department store and the salesperson gave us registry cards to include with our wedding invitations. I'm not sure about this. What's the right thing to do?**

No mention of gifts or anything associated with gifts, like a list of registries, is ever put on or included with a wedding invitation. No matter what store staff tell you, don't include registry cards with your invitation. Although it might seem practical, it's perceived as greedy and puts the emphasis on the gifts and not on the invitation to join a couple on their special day. Registry information also shouldn't be included with invitations to an engagement party or with a wedding announcement.

❋ **Can registry information be included with a shower invitation?**

Yes, shower hosts may include a separate sheet listing where the couple is registered. After all, gift giving is the whole point of a shower.

❋ **This is my second marriage. How do my fiancé and I let people know that we don't want any gifts?**

Again, the best method is a strong word-of-mouth campaign by family, friends, and attendants. If you're asked directly, it's

fine to let people know: "John and I have everything we would possibly want. Having you at our wedding would be the best gift we could receive."

✳ Is there a tactful way to put the word out that we want cash, not gifts?

Cash gifts are perfectly acceptable if the guest feels comfortable with the idea. Even though cash gifts are traditional in some areas and cultures, some people just don't like to give money as a gift, and that's their prerogative. Use the grapevine to let guests know your preference, or, if you're asked directly, you might say: "We're saving for dining room furniture, so if you like the idea of giving a check as a gift, that's how we'll use it. Whatever you decide would be terrific! Thank you for thinking of us."

SMOOTHING THE WAY: *It's a good idea to set up a traditional registry, even if it only has a few items on it, so that guests who prefer to give a gift will have an idea of what you like and might need.*

✻ **We'd like to have our silverware monogrammed. How should it be marked?**

Today, a triangle of block letters—last-name initial below and first-name initials of the bride and groom above—works well on modern patterns.

$$J \quad T$$
$$N$$

If a last name initial is used, then use:

N, the initial of the groom's last name;

B-N, the couple's last name if hyphenated; or

B•N, if the bride keeps her maiden name.

Consider having the store hold off on the monogramming until after the wedding, in the unlikely event the wedding is called off.

✻ **My fiancé and I have been living together for a long time and have a pretty established household. Do we have to register for china and silverware?**

No, you don't. Nowadays, there are many creative alternatives to the traditional gift registry. It's perfectly acceptable to reg-

ister for a house down payment, a honeymoon trip, or camping equipment. When used appropriately, these alternatives can provide guests with relevant gift choices, helping couples receive items they can use and truly enjoy as well as items their guests enjoy giving. As with all gift information, the key is to share it appropriately the old-fashioned way, by word of mouth. Let your helpers know the reason for your preference, so they can explain: "They've always dreamed of a trip to China;" "They're hoping to save enough money for a down payment on a house;" "They love the outdoors and are planning to hike the entire Long Trail." Still, it's a good idea to register for a few traditional items as well. And if you're asked, let your guest know your preference, but add, "Of course, anything you choose will be wonderful!"

❋ **My partner and I are planning our commitment ceremony and reception. Is it okay for us to register for gifts?**

Yes, it's perfectly fine for you and your partner to register for gifts—it's a convenience for your guests who, most likely, would like to send you a gift to celebrate your happiness.

❋ **Where do we tell guests to send wedding gifts?**

Before the wedding, gifts are usually delivered to the bride's home, addressed to her using her maiden name. After the wed-

ding, they're addressed to the couple and sent to their home. Today, gifts may be sent to the couple if they're already living together. Online and store registries have made it easy, as the bride and groom will have specified where the gifts will be sent and the store or service takes care of the delivery.

✳ It's customary to bring gifts to the wedding in our part of the country. Should we open them at the reception?

When gifts are brought to the reception, a special table for the gifts is set up in a safe place. Unless it's a very small wedding, the bride and groom aren't expected to open their gifts at the reception; it would take far too long, and they should spend their time mingling with their guests. Instead, the couple or the hosts should arrange for someone to oversee the presents and transport them to a safe place after the reception. The couple will appreciate the gifts more if they can open them at their leisure. The job takes time and effort, so be sure to thank your attendant afterward—in writing and with a small token of appreciation.

✳ Is record keeping necessary? Can't I just attach the card to the gift?

Good record keeping is critical: Gift cards can easily be lost or mixed up, and it's hard to remember who gave what. Keeping

a record helps you associate specific gifts with the givers, personalize your thank-you notes, and say something nice when you next see your guests. Some couples keep track in a written ledger and others take advantage of a computer-based spreadsheet. Either way, you'll need to know the following:

The date the gift was received.

The name and address of the giver or givers. Save the card to double-check spellings.

A clear description. Be really specific. Writing "platter" won't help you if you received three, but "18-inch pottery platter, sunflower" or "4 monogrammed pillowcases, pale blue" will immediately identify the gift.

Where it was purchased. Note the store, catalog, or online service, if known.

When the thank-you note was sent.

It's also a good idea to number your gift log and attach a corresponding number to each gift. If your gifts are being delivered to several addresses, it's important that everyone keep good records for you.

❋ Who gets a thank-you note?

Everyone who gives you a wedding gift should receive a prompt thank-you note. This also includes people who've handed you a present, no matter how enthusiastically you thanked them in person. Written notes show that you care enough about the giver to compose an individualized message and put the words on paper. Write to each person or couple who contributed to a group gift. If the gift is from a family, all living at the same address, one note to all is appropriate. The one exception is for a gift from a large group of coworkers. Ideally, each would be thanked, but in this case it's acceptable to write a note to the group and ask that it gets passed around the office or posted for all to see.

❋ We started receiving wedding gifts right after we sent the invitations. Should we send thank-you notes now, or wait until after the wedding so we can thank guests for coming?

Now is definitely the time to thank the early gift-givers. Ideally, you write the note on the day you receive the gift. It's a lot easier to keep up with the note writing by doing some every day rather than facing the daunting task of having to do all of them right after the wedding. A prompt note assures the sender that the gift arrived in good order. In any case, your thank-you notes should be completed within three months of the receipt of each gift.

✳ Is it okay for my fiancé to write the thank-you notes to his family and friends?

Absolutely! Today's couples share the responsibility, which helps the job go faster. It also makes personalizing the notes easier; each of you can write to the people you know best. But it's fine to write to each other's relatives and friends—it's a great way to build new relationships. Even though you sign the note with your name, don't forget to include your fiancé(e)'s thanks in your message.

The Perfect Thank-You Note

MENTIONS GIFT IN A COMPLIMENTARY, NON-GUSHY FASHION.

Dear Mr. and Mrs. Gresham,

GREAT WAY TO FOCUS ON THE GIFT.

I'm looking right now at the lovely silver candy dish you sent and imagining how pretty it will be on our

SAYS HOW THE GIFT WILL BE USED.

Thanksgiving table next month. (We're hosting Paul's family for the first time!) It really is one of my favorite things and Paul and I are so grateful to you.

THE "OFFICIAL" THANKS FROM THE COUPLE.

A PERSONAL, CONVERSATIONAL NOTE.

We were both sorry that you couldn't come to the wedding, but I know your trip to New Zealand must have been amazing! If all goes according to plan, we will be in St. Paul for Christmas, and we'd love to see you and the girls and hear about your travels.

PLANS TO KEEP IN TOUCH.

Again, thank you so much for the candy dish and for the beautiful thoughts in your note.

ACKNOWLEDGES A THOUGHTFUL GESTURE.

Love from both of us,

INCLUDES THE GROOM IN THE CLOSING.

Courtney

❋ **We're having a huge wedding. Can I just post a "thank you" on our Web site instead of writing individual letters, or could I send an e-mail blast?**

You could certainly post a message or send an e-mail thanking everyone for sharing your special day, but they're not substitutes for personal notes of thanks for your gifts. Likewise, just signing a card with a preprinted message shows very little consideration, as does a short, generic, one-size-fits-all note. You and your fiancé should take the time to write warm personal notes to each person who gives you a wedding present.

❋ **What do I do about gifts that didn't include a card? I don't want someone to think I'm ungrateful because I didn't write a note.**

This is a fairly common problem and one where good record keeping will come to your rescue. Do the best detective work you can. Check the packaging and call the store or service where the gift came from and see if they have a record of who sent the silver candy dish. If that doesn't work, pull out your guest list and cross off the names of those you've already thanked. Hopefully there will only be a few names left. You can call those guests and delicately inquire whether they gave you the candy dish or the blender. If it's still a mystery, write those guests

who attended your wedding but for whom there was no "gift received" checked on your list, and thank them for sharing in your big day. If a gift was sent, but not mentioned in your note, you'll probably get a call asking what happened.

✳ My aunt and uncle sent us a check as a wedding present. Should I mention the amount in my note?

You should definitely thank anyone who gives you money—cash, checks, contributions to savings or investment accounts, gifts to charity. It's optional whether you mention the amount, but doing so lets the giver know that the currency arrived in good order or that an account deposit was correct. Always let the giver know how you plan to use their gift.

> *Dear Aunt Mavis and Uncle Tom,*
>
> *Joe and I are overwhelmed by your generous check for $500. We'll add it to our "house fund" and hope to surprise you with the news when we can actually make a down payment on our own home. I'm so happy that you'll be sharing our special day, and that Joe and I will be able to thank you in person.*
>
> *Much love,*
> *Susan*

✳ I have special note cards with my new name on them. May I use them for my thank-you notes now, or should I wait until after the wedding?

Definitely write thank-you notes as soon as the gifts arrive, but use notes that have your maiden name or initials, or other pretty note cards for letters you write before the wedding. Save your new stationery with your new name or initials for notes written after you're married.

✳ We just opened a gift that, unfortunately, arrived broken. What should we do?

When a gift arrives broken from a store or service, simply return it or arrange for an exchange. Any reputable store will replace merchandise that arrives damaged. There's no need to mention anything to the giver. But if the gift arrived from the giver directly, check to see if the package was insured. If so, you'll need to tell the giver so they can file a claim and replace the gift. If it wasn't insured, you might not want to mention it because the giver may feel obligated to replace it.

❋ **We received two toasters. Is it okay to exchange one?**

Sure, but do so discreetly. Simply thank the giver for the present—you don't have to explain that you exchanged it. If a friend realizes that she's given you a duplicate gift, she should encourage you to exchange it. In that case, thank her for her thoughtfulness and let her know what you chose instead.

❋ **My fiancé and I are planning to give gifts to our attendants. Is there anything we should keep in mind, and when should we give them?**

Traditionally, the bride chooses gifts for her bridesmaids and the groom chooses for his groomsmen and/or ushers, but that doesn't mean you can't choose the same gift for all. Gifts needn't be expensive, but should be meaningful and com- memorate the occasion. This isn't the place for joke presents. If you have children in your wedding party, look for personal and age-appropriate gifts that will be a special treat. Gifts may be presented at the rehearsal, the rehearsal dinner, or at bridesmaids' or groomsmen's parties. It's not a good idea to present them at the wedding, where they could be lost or stolen.

✳ **Should I send thank-you gifts to those who gave parties for us or who hosted guests?**

Yes, if it fits your budget, then flowers or a small gift is a lovely way to thank people who've hosted parties, provided rooms for guest or attendants, or who have performed other favors or special duties for you. If gifts aren't possible, be sure to send a thank-you note.

CHAPTER 8

your ceremony

❋ Is it okay for a bride to wear white if she's been living with her fiancé or has been married before?

Today, white symbolizes joy and celebration. Many couples do live together before marriage, and it's fine for the bride to wear a formal white or ivory gown. Similarly, a second-time bride may choose to wear a formal gown, or take a more low-keyed approach. She may choose white or any color she wishes. It's also okay to wear a veil (a requirement for some religions) that matches the style of the dress, but the blusher veil or long frilly veils are better suited to young, first-time brides.

✳ **My fiancé was married before in a large, formal wedding. I've never been married and have always dreamed of a formal wedding. Since this is his second wedding, should we have just a simple ceremony, or may we have a formal wedding?**

Go ahead and plan the wedding of your dreams: Simple or lavish, formal or informal.

✳ **Are there any rules about choosing the hour of the ceremony?**

No, but whatever time you choose, it's best to plan the reception to follow the wedding, if possible. It's customary to provide refreshments for your guests, which can run the gamut from something light—iced tea and sandwiches—to a full meal. If you plan a noon wedding, or a wedding between 4:00 PM and 8:00 PM, your guests will be expecting a meal, or at least some substantial food.

✳ **Should the reception immediately follow the ceremony?**

Ideally, yes. People do expect a delay, but any longer than thirty or forty minutes is excessive. Make sure someone from the wedding party—parents or attendants—is able to greet guests at the reception site and, if there's a long delay, be sure guests are served food and drink.

Sometimes circumstances make it impossible for the reception to follow the ceremony, and there is a delay of several hours. It does make some extra demands on your guests: They may have to change outfits for the reception or find a meal on their own. Your guests will know this from their invitation, but it's a good idea to include suggestions for local restaurants and possible activities with the invitation.

❋ **What does the bridal party wear for formal, semiformal, and informal weddings? Are there any guidelines?**

For a formal wedding, the bride wears a long gown, as do her bridesmaids. If the wedding is in the morning, the groom and ushers wear cutaways or morning suits, and in the evening they wear either white tie or a tuxedo.

At a semiformal wedding, the bride and her attendants wear long, ballerina, or tea-length dresses. The groom and groomsmen may wear a dark suit in the daytime, or a tuxedo or a dark suit in the evening.

At the informal wedding, the bride and her attendants wear simple long gowns or ballerina, tea-length, or cocktail-length dresses. The groom and his attendants wear suits or a jacket, tie, and slacks.

✳ **My fiancé is in the military. Should he wear his uniform for our wedding?**

Brides and grooms in the service may wear either civilian clothes or their uniforms, as may their colleagues who serve as attendants. Depending on the formality of the occasion, everyday and dress uniforms are equally correct, since young and noncareer personnel don't have dress uniforms. For a formal wedding, commissioned officers wear evening dress uniforms, the equivalent of civilian white tie. Dinner or mess dress is the same formality as a tuxedo. Noncommissioned officers can wear dress or everyday uniforms for formal and informal ceremonies.

Regulations vary by service branch, but generally only commissioned officers in full uniform wear swords. Hats and caps are carried during an indoor ceremony, and gloves are always worn by saber or cutlass bearers. Flowers are never worn on uniforms (no boutonnières!) but brides in uniform may carry a bridal bouquet. Service members not in uniform and nonmilitary members of the wedding party dress as they would for the formality of the ceremony.

✳ Should my mother and my fiancé's mother wear the same length and style of dress?

It may be your day, but your respective mothers want to shine, too. They should choose clothing in keeping with the style of the wedding. This is where brides can be very helpful by encouraging "the moms" to work together in choosing their outfits. Yes, the bride's mother gets first choice, but that doesn't mean that the groom's mother is restricted to beige. And matronly is out, too. Fashionable and age-appropriate is in.

Think photographs! The moms shouldn't wear the same color as the bridesmaids—they won't stand out. They also shouldn't wear the same color as each other—too confusing. Variations on the color scheme are fine, as long as each mom's dress color is distinct. The length of the gown is their choice, even for formal weddings. Long dresses and skirts are fine for weddings from noon on. The moms don't have to wear the same length dress, but many do, feeling that doing so creates a more harmonious look, especially in photos. (In the best of all possible worlds, the two moms have a bonding/shopping excursion on their own.)

✳ What should the fathers wear?

If they participate in the ceremony, fathers and/or stepfathers usually wear the same outfits as the groomsmen. This is also the case for any man who escorts the bride down the aisle.

When the groom's father doesn't have an active role, he can either match the formality of the male attendants or "dress down" a bit—choosing a tuxedo or dark suit instead of more formal attire. But if he's going to be in the receiving line, his outfit should conform to that of the bride's father and the groomsmen.

✳ What do the "Best Woman" and "Man of Honor" wear?

This is easy. A male honor attendant wears the same attire as the groomsmen, although his tie may match the color of the bridesmaids' dresses or his boutonnière the bridesmaids' flowers. A "Best Woman" may wear a dress in the same color family as the bridesmaids', or she can wear a dress in black, gray, or whatever main color is worn by the groomsmen, with accents that match their ties. Her attire should be in keeping with the formality of the wedding, but normally she wouldn't wear a tux or match the groomsmen's suits. She wears a corsage that features the same flowers as the groomsmen's boutonnières.

❋ What do flower girls, ring bearers, junior bridesmaids, and junior ushers wear?

Junior bridesmaids and ushers wear the same clothing as their adult counterparts, although the junior bridesmaid's dress should be adapted for her age and size. For example, if the bridesmaids are wearing strapless dresses, a twelve-year-old bridesmaid could wear a strapped or short-sleeved version.

Traditionally, the flower girl wears a white or pastel mid-calf dress with white socks and "party shoes." The dress could be a version of the bridesmaids' dresses, but make sure that it's suitable for a little girl. She could wear a wreath of flowers and/or ribbons, or have flowers braided in her hair. (Be sure you have a cooperative subject, or skip this step!)

Ring bearers, train bearers, or pages usually wear white Eton-style jackets or a blazer, white shirt and bow tie with short pants, white socks, and dress shoes. Older boys may wear a dark suit or blue blazer with long, dark pants, button-down shirt, tie, dark socks, and dress shoes. Avoid the tuxedo—it looks overdone on boys younger than high-school age.

✳ **My dad died a few years ago. Who should walk me down the aisle?**

Think about the people who are important in your life: A brother, uncle, godfather, close family friend, or even your mom are all excellent choices. If you're close to your mom, this could add extra significance for you both. If there really is no relative or friend who can escort you, you may walk alone. It's also acceptable, but pretty untraditional, for the groom to escort his bride to the altar.

✳ **My father, mother, and brother are all equally important to me. Can they all walk me down the aisle?**

Sure they can, and it's wonderful that you want to honor each of them in this way, but think this through to its conclusion: Will your family feel awkward? Can four people walk abreast down the aisle? There are some alternatives that might accomplish your goal more easily. Both your parents could escort you down the aisle, and your brother could precede you as a "Best Person." Your fiancé could ask your brother to be one of his ushers and he could escort your mother, and your father could escort you. Or you could incorporate a family prayer into the ceremony or propose a toast to these three special people at the reception.

✳ **I'm closer to my stepfather, who has played an active role in my life, than to my biological father. He's also paying for my wedding. How do I tell my biological father that I'd like my stepdad to walk me down the aisle? Should I avoid the whole problem and just walk alone?**

Choosing between parents may be one of the hardest decisions a bride has to make. If they're cordial to each other, you could ask both to escort you down the aisle—it's rare, but not unheard of. Or your biological dad could walk you half-way and meet your stepfather, who then escorts you to the altar. But if you truly think your stepfather should be the one, you'll have to have a heart-to-heart with your biological dad and gently tell him your plan.

SMOOTHING THE WAY: *If you need to make decisions regarding divorced parents or stepparents, make them early on in your planning. Don't wait until the rehearsal to make these decisions. It's important to speak to those involved well ahead of the actual event, so when the time arrives, everyone knows what's expected. You can be firm in your decisions, but keep the conversations sensitive and respectful.*

✷ This is my second wedding. Should my father walk me down the aisle?

Your father can escort you down the aisle, even if it's your second wedding, and it's fine to ask him to perform this honor. Or you can walk down the aisle alone, since there's no requirement that the bride be escorted.

✷ Is it still the custom to "give the bride away"? Can you offer an alternative to the question "Who giveth this woman . . . "? in the wedding ceremony?

Yes, long gone are the days when marriages were more about a financial arrangement between families than the personal choices of a man and a woman. The idea that a family, represented by the father, "gives away" its female children connotes that the girls are property, but the boys are independent free men. In American culture today, that's certainly not the case, but the tradition has lingered and is a basic part of the wedding service.

Talk to your clergyperson and see if you can change this part of the ceremony. Some other options you might suggest are: "Who represents the families in blessing this marriage?" to which both your parents respond, "We do," or your father could say, "Her mother and I do." The groom's parents could

also respond to the question. Another suggestion is to ask the congregation as a whole, "Who will support and bless this marriage?" to which the entire congregation responds, "We do."

❋ Does the bride walk down the aisle on her father's right arm or left arm?

The bride walks down the aisle on her father's right arm.

❋ Where do the two families sit during the ceremony?

The parents of the couple always sit in the first pew, along with any siblings or children of the bride and groom who aren't in the wedding party. The bride's family sits on the left facing the altar; and the groom's family on the right. Then immediate family—grandparents, aunts and uncles—sits in rows behind the parents. Usually, the bride prepares a seating chart and sends pew cards to family, telling them in which row they're seated.

If there are two aisles—meaning two side seating areas and one center seating area—only the center section is used. The parents of the bride sit on the left side of the center section and the groom's parents sit on the right side of the center section.

❊ What part do grandparents play in a wedding?

Your grandparents are treated as most honored guests. Seat your grandparents directly behind your parents at the ceremony or, if you prefer, seat them in the same row as your parents. At the reception, seat them at the parents' table. It's also a nice touch to present the grandmothers with corsages, too.

❊ My parents are divorced and each has remarried. Where do they sit in the church?

When either the bride's or the groom's parents are divorced the seating needs to be planned carefully and the ushers need clear instructions. It can be tricky: Divorced parents may or may not get along; or the bride may be close to one parent and not another. Tact and diplomacy will be critical for keeping the peace.

Let's use the bride's parents as an example. Unless the bride is completely estranged from her mother, her mother (and stepfather, if mom has remarried) sits in the front pew on the left side as you face the altar. Members of her mother's immediate family—the bride's grandparents, aunts and uncles—sit immediately behind in the next one or two pews. The bride's father, after escorting her to the altar and presenting her to the groom, sits in the next row behind the bride's

mother's family—usually the third or fourth—with his wife and his family members. This protocol is followed even if the bride's father is hosting the wedding. In the lucky event that all the parties get along, there's no reason why the divorced parents cannot share the first pew. It's only when there is strain or outright bitterness that you use etiquette to prepare a careful, well-thought-out alternate seating plan.

✳ Do friends of the bride always sit on one side of the church and friends of the groom on the other?

Facing the altar, the left side of the church is the "bride's side" and the right side of the church is the "groom's side." But if one side clearly outnumbers the other, it's considerate of the ushers to even out the seating.

✳ How and when do we seat latecomers?

No one is seated from the center aisle after the mother of the bride is taken to her place. Latecomers must stand in the vestibule, go to the balcony, or slip into a back pew from the side aisles until the wedding party has finished processing. Then ushers can help to seat the latecomers discreetly.

✳ What's the standard order of the processional?

The entry of the bride and groom can vary among cultures and religious traditions. In the typical, nondenominational processional:

- The ushers lead the processional, two by two, shortest men first.

- The junior ushers follow the adults.

- Next, the junior bridesmaids.

- Then the bridesmaids, walking in pairs or singly, leaving about a twenty- to thirty-second pause between each group.

- The maid or matron of honor follows the bridesmaids.

- The ring bearer comes next, followed by the flower girl.

- Finally, the bride enters. She is to the right of her escort, and links her left arm through her escort's crooked right arm.

- At this point, the guests stand while the bride processes.

✳ If I wear a veil over my face, when is it turned back?

You father turns back your veil before he leaves your side, or your maid of honor turns it back before your final vows. Check with your officiant, and make sure to practice this during the rehearsal so that it goes smoothly.

✳ When do I give my flowers to my maid of honor to hold during the ceremony?

Give your flowers to your maid of honor after you turn to face the altar. She'll give them back to you after you've kissed your husband, as you turn to face the congregation for the recessional.

✳ My sister died recently and I'd like to honor her during our ceremony. Is there any way to do this?

It's understandable that you'd like to memorialize your sister. The important thing is not to make it upsetting to your family and guests. Something prominent, like a large photograph displayed at the reception, would be a painful reminder and put the focus on your family's loss, and not on the celebration of your wedding. A simple declaration of love, a moment of silence, the lighting of a candle, or laying special flowers on the altar can be eloquent commemorations. More privately,

you could wear or carry something that belonged to her. This could also be a way to remember a deceased parent.

❊ My fiancé and I would like to personalize our wedding by writing our own vows. Are there any guidelines?

Your wedding vows are the expression of your personal commitment to each other. Make sure that you discuss this with your officiant well ahead of time. Most clergy are willing to allow variations to the traditional vows, as long as the basic marriage vows are expressed in one form or another. In most religions, these are the promises to be true to each other in good times and bad, in sickness and in health, to love and honor each other "until death do you part," and to respect and cherish each other. If you decide to write your own vows, think about the following:

- Make sure your vows express who you are, and your beliefs and sensibilities.

- Avoid sweeping generalizations; make your words personal and meaningful.

- Keep it simple and brief; avoid overblown metaphors and clichés.

- Even if you memorize your vows, give your officiant a written copy in case you need prompting.

- If you come from two different cultures, religions, or traditions, it's nice to include vows that commit to building bridges of understanding and honoring each other's traditions.

✱ Does my wedding ring go on my finger over my engagement ring?

Here's a lovely tradition that requires a little bit of preparation on your part. On your finger, your wedding ring should be closest to your heart. Before the ceremony, switch your engagement ring to your right hand. The groom can place your wedding ring on your finger—closest to your heart—and then you can slip your engagement ring back on top.

✱ How are the fees delivered to the officiant?

Deliver the fees for the use of the house of worship, the officiant, the organist, soloist, or cantor in a sealed envelope, addressed individually. Include the payment (cash or check) and a handwritten thank-you note. The groom prepares these envelopes ahead of time and either delivers them personally or gives them to the best man to distribute.

✳ **My fiancé has just been called up for active duty and we want to marry before he leaves. If we have a civil ceremony now, can we have the church wedding we planned when he returns?**

Many couples are faced with this situation for a variety of reasons, military call to duty being the most prominent. When you've had a civil ceremony, it does change the nature of any religious ceremony that you want to have afterward. Technically, it's not a wedding, because you're already married. However, in many faiths, you can have a blessing of the marriage or you can have a service that is a reaffirmation of your vows. Talk this over with your clergyperson so that you can plan the appropriate ceremony: Usually, the wording of the ceremony reflects that the marriage has taken place, no one gives the bride away, and rings are not re-exchanged. Given your circumstances, it's fine to have your bridal party present, and to wear the gown that you might not have had a chance to wear at your civil ceremony.

✳ **Do we need to have wedding programs?**

No, but they are a smart addition, and can be especially helpful to guests of other religions who may not be familiar with your service. This is particularly true when the wedding is a mix of religions and cultures and not all guests necessarily

understand the liturgy or ritual. But don't get carried away—they're not Broadway playbills, and you don't have to give a bio for every bridesmaid and usher. (Okay, tiny bios that list the relationship to the bride and groom are helpful, especially when there has been divorce and remarriage.)

Most programs list the order of the service and directions for standing and sitting, list the page numbers for hymns to be sung by the congregation, and include any prayers or responses expected from the congregation. The program can be an opportunity to explain the meaning behind certain rituals and customs. It's also nice to include a "who's who" of the wedding party and, if all are invited to the reception, directions to and the phone number of the reception site. Last but not least, it's a great place to put a reminder—near the top!—to turn off cell phones, pagers, and the like.

❋ How do my partner and I go about planning our commitment ceremony?

Usually, gay and lesbian couples either create their own traditions or follow the outline of a traditional wedding ceremony. Your ceremony can be religious or secular, and you're free to plan the kind of ceremony that's meaningful to you. While there are many religions that refuse to be associated with commitment ceremonies, there are others willing to affirm same-

sex unions in one way or another. The services and the names for the services vary among religions, and some clergy, within the structure of their religion or outside it, will perform a ceremony that acknowledges the commitment of the couple.

Because many churches do not sanction a gay or lesbian union through wedding liturgy, you actually have more latitude in planning your ceremony. You may write your own vows, using religious or secular sources. Commitment ceremonies usually include the following:

- An introduction, such as a processional, gathering together, welcome, and invocation

- The service, which can consist of prayers, songs, readings, and a homily or address by the officiant

- An exchange of vows that express the couple's intent

- A blessing and/or exchange of rings

- The official pronouncement by the officiant that the couple is recognized as married

- The closing, which may include the kiss, the blessing of the union, and the recessional

❉ What do I need for a civil ceremony?

A civil ceremony is simple and brief. You'll need to fulfill the legal requirements (documents, health testing, etc.) and, usually, provide two witnesses.

❉ Do I have to have a civil ceremony at the town offices?

No, you can arrange to have a civil ceremony at home, in a garden, at your reception site—almost anywhere! Make sure to arrange the travel needs for your officiant and coordinate with the reception site to arrange seating and decorations for the ceremony.

❉ Can a civil ceremony be personalized?

Sure. Just arrange with the justice of the peace or whoever will officiate to discuss the length of the service and the list of elements you wish to add.

CHAPTER 9

your reception

✳ **Who stands in the receiving line? The groomsmen are nervous and want to know what to do.**

The groomsmen are off the hook—they usually don't stand in the receiving line. The receiving line consists of (in order): the mother of the bride, the father of the bride, the mother and father of the groom, the bride and groom, the maid or matron of honor, and one or two bridesmaids. It's optional for the fathers to stand in the line; they can also circulate among the guests. If the wedding party is small, then the best man and groomsman may join as well.

�µ **My fiancé is really shy and doesn't want to have a receiving line. Is it okay not to have one?**

A receiving line isn't required. However, you and your husband should greet and thank each guest for coming to your wedding, and a receiving line is the best way to ensure you do that, especially if your wedding is large. At a small wedding, you could skip the receiving line and spend a few minutes at each table during the meal, greeting and thanking your guests.

If you decide to have a receiving line, reassure your fiancé that it's actually pretty simple and plan to move it along quickly. You can also help him by cluing him in as to whom he's greeting: "Josh, this is Aunt Tara from Cincinnati." Then your fiancé should have a few stock remarks that are easy for him to say: "Nice to meet you and thank you for coming all this way." Keep it short and simple, and make sure your maid of honor is primed to rescue him if a guest starts chatting.

�µ **We can't decide when to have the receiving line: at the ceremony site or at the reception. Any advice?**

If your wedding is small, or if most people invited to the ceremony aren't invited to the reception, then it's fine to form the receiving line after the ceremony and greet guests as they leave the church. Otherwise, it's best to have it at the reception site and greet guests as they arrive. If the receiving line is

at the reception site, it's thoughtful to have the waitstaff offer drinks to those waiting, and provide a table where guests can place their drinks while going through the line.

❋ **I just went to a bridal fair and there was a lot of talk about reception dresses. Is it still acceptable to wear my wedding dress to the reception?**

Absolutely! This trend started with celebrity weddings, lavish affairs where the bride may have showcased several gowns by big name designers throughout the event. It may be the latest addition to the fairytale wedding and the bridal fashion industry, but for most brides, their wedding gown is the dress for the day. Of course, a change of outfit may be called for if your gown isn't a match for your reception, such as a clambake or barbeque. And some brides who want to dance the night away may prefer to wear something less formal. If you are wearing a different dress, don't forget to factor in time to change and a place to do it.

❋ **When's a good time to take the wedding photographs?**

If the photographs are taken before the reception starts, keep the session as brief as possible. Organize the schedule carefully with the photographer and be sure to inform your wedding coordinator as well. It's good to review these instructions with the wedding party at the rehearsal so that everyone's pre-

pared to be prompt, and knows where to go and what photos will be taken.

Alternatively, the photos can be taken after the receiving line is finished and guests are having cocktails, or take some shots before the receiving line and the others later during the reception. But whatever your schedule, don't leave guests in limbo while you pose for endless pictures!

❋ **We plan to have our photographs taken between the ceremony and the reception. Will there still be enough time to have a receiving line?**

Depending on the number of photos that you want taken, you might not have enough time for both activities. You don't want to leave your guests hanging for any length of time. If the pictures will take more than twenty to thirty minutes, it's best to skip the receiving line. Just make sure you greet each guest at some point during the reception. Also, have the DJ or bandleader introduce the bridal party and the bride and groom's parents, so guests know who's who.

❋ **My parents are divorced. Should they both be in a photo with me and my husband?**

No, it's best for each parent and their respective spouses separately to have a picture taken with the couple.

✳ **Should stepparents be included in the wedding photographs?**

Be as inclusive as possible, while respecting everyone's comfort level.

✳ **My parents are divorced. Do they both stand in the receiving line?**

Divorced parents don't stand together in the receiving line. When the bride's divorced parents are on friendly terms and accept each other's new spouses, or when both sets of parents are hosting the wedding, then they may all stand in the receiving line, separated by the groom's parents to avoid any confusion. If the groom's parents are divorced and remarried as well, then the bride's parents alternate with the groom's, so no one stands next to his or her ex-spouse. More important than the lineup is how everyone feels about it. Talk to your parents early on about what you'd like to do and how you plan to implement it.

✳ **Who sits at the table with the bride and groom?**

When there's a bridal table, the bride and groom sit at the center, facing out so that guests can see them. The bride is on the groom's right and the maid of honor on his left. The best

man sits on the bride's right. Then attendants sit on either side, alternating male-female if possible.

✳ **Many of our attendants are married, but we don't know their spouses and the spouses don't know many of the guests. Should they be seated at the head table or with other guests?**

Seat all your attendants together with their husbands, wives, fiancé(e)s, and significant others, especially if they don't know many other people at the wedding. If you don't, they may feel unwelcome. If that makes for an ungainly table, consider having a small head table that consists of you and your groom along with the best man, the maid of honor, and their partners. Then seat the remainder of the bridal party and their spouses at an adjacent table.

✳ **Who sits at the parents' table?**

The bride's and groom's parents, the grandparents, and the officiant and his or her spouse are all included at the parents' table. If there's room, godparents or other very close relatives or friends could be included.

✻ **Where should my mother, stepfather, father, and father's girlfriend (who is despised by my mother) sit at the reception?**

In a word? Separately! At the reception, seat your mother and stepfather and your father and his girlfriend at separate tables. Seat them across the room from each other if necessary—and hope that your mother, and everyone else, can put aside ill feelings for this special day.

✻ **Should we have assigned seating?**

It's a good idea to have assigned seating at sit-down or buffet receptions. Deciding who sits with whom takes some time and needs tact and diplomacy, but a good seating plan—one that mixes generations and interests, and introduces new and old friends—can make for a memorable wedding. If you don't want to get as detailed as having place cards, guests can be assigned to tables, and then seat themselves.

SMOOTHING THE WAY: *If you opt not to assign seats or tables to guests, in addition to the bridal party table have at least one other assigned-seating table reserved for your elderly relatives and friends. It will make them feel comfortable and honored.*

❋ **Do you have any tips for creating a good seating chart?**

A friend employed a great method. She printed labels for all the guests—one couple or a single person to a label. Then she attached the labels to different colored sticky notes: Blue for the bridal party, pink for the bride's family, orange for the groom's family, lavender for friends of the bride, and green for friends of the groom. She had a large board marked out with all the tables. As she assigned the seating, the different colored "stickies" made it easy to see if her tables were balanced, and it was also easy to move guests around until she was satisfied that she had created congenial tables.

❋ **An old friend has discreetly asked me not to seat her with one of our other guests. Actually, I had planned to seat them together, but my friend said they've had a recent falling-out. Should I comply with her request?**

As the bride, you decide who sits where and each guest has an obligation to accept his or her seating assignment and take the high road when it comes to conversing with others at the table. Still, you want your guests to be comfortable and enjoy themselves, and a fun time for guests makes for a happier celebration. She probably wouldn't have asked unless she genuinely thought it would be a problem. It would be kind to respect

her request if doing so doesn't completely disrupt your seating plan. If you can't move her to another table, then be sure that these two guests are not seated next to each other.

✳ Who should be master of ceremonies?

It's a good idea to have someone be master of ceremonies to keep the reception running smoothly. The band leader or DJ can make the necessary announcements; just be sure you like their style. Even the father of the bride, as host, can welcome guests, invite his daughter to dance with her new husband or announce that the cake will be cut. Alternatively, the best man can make any announcements or introductions.

✳ What's the order of the toasts?

Traditionally, the best man offers the first wedding toast. This occurs as soon as the champagne is poured—when everyone is seated at a sit-down dinner, or as soon as the couple enters the reception if it's a cocktail buffet. Then it's the groom's turn to toast his bride. The fathers of the bride and groom may each follow with a toast of their own, welcoming guests and saluting the newly married couple. Now others may give toasts.

✴ What's an appropriate toast?

At a reception, toasts should be short and sweet, lasting no more than one to two minutes at most. Or they can be a simple salute to the couple: "To Jessica and John—two very special people. May you always be as happy as you are today." Resist the urge to monopolize the microphone with a long rambling story or to regale guests with tales of either the bride or groom's single life. You'll only embarrass yourself.

✴ Are congratulatory telegrams, faxes, notes, or e-mails read aloud?

After the toasts have been given, the best man reads aloud faxes, notes, or other messages from guests who were unable to attend the wedding. He then gives them to the bride's parents for safekeeping so that the bride and groom can acknowledge them when they return from their honeymoon.

✴ After we dance the first dance, what's the order for dancing at the reception?

After the bride and groom dance the first dance together, there's often a "second dance" and (sometimes even a third) in which the bride dances with her father and the groom dances with his mother. To make things just a little bit complicated and

keep everyone on their toes, midway through this dance, the groom's father cuts in and dances with the bride. The bride's father then cuts in and dances with the groom's mother, while the groom asks the bride's mother to dance. After that, the dancing is open to everyone, and, hopefully, everyone dances all night!

❊ When's a good time to start the dancing?

To keep things moving at the reception, it's fun to start the dancing early on. At one wedding I recently attended, the bride and groom danced their first dance just after guests were seated, while the first course was being served. Needless to say, the dancing began early, with lulls during courses, and lasted until the end of the reception. It was wonderful!

❊ I have both a father and a stepfather and am worried about which to choose for a father/daughter dance. What can I do?

You can open the dancing to everyone right after you and your groom dance. Just be sure to dance with your father and your stepfather at some point during the reception.

❋ **My fiancée and I can't agree on the cake. She's vanilla, I'm chocolate. And our parents are really traditional. Any advice?**

What a sweet problem! First, reassure your parents. No longer is wedding cake white, white, white—and pretty bland-tasting as well. Today's brides and grooms want a yummy, gorgeous cake to serve their guests. You might as well invest in one that's delicious as well as beautiful. Cake decorating has become quite an art form, limited only by your imagination. As to the chocolate versus vanilla battle, how about a compromise and alternate layers or have one side chocolate and the other vanilla?

❋ **What is "groom's cake"?**

Traditionally, groom's cake was a fruitcake that was sliced and packaged in little white boxes, monogrammed with the couple's combined initials and tied with satin ribbon. It was given to guests as a memento—an early form of wedding favor. Tradition also said that if an unmarried woman put the box under her pillow, she would dream of her future husband. Today, groom's cake is an alternate cake expressing his personality, say a chocolate cake, which is served to guests who prefer it to the wedding cake. Either way, the cake is usually provided by the bride's family.

✳ When is the wedding cake cut, and what's the procedure?

At a reception with a sit-down meal, the cake is cut at the end of the entrée course. Typically, the person acting as master of ceremonies announces the cake cutting, at which point the bride and groom proceed to the cake table.

The bride places her hand on the knife handle, and the groom places his hand over hers. They cut off a small piece of cake and place it on a waiting plate that has two forks. The groom feeds the bride the first bite, she feeds him the second, and they kiss. (Please: no smashing cake into each other's mouths—it's tacky, messy, and requires makeup repair!) The cake is then taken to the kitchen where it's sliced and served for dessert.

✳ Doesn't the cutting of the cake signal that guests may leave the reception?

Yes. In days past, the cake was cut at the very end of the reception and, for some guests, it was the magic moment that meant they could leave a sometimes overly long wedding. Not everyone wants to party 'til the band quits. Today, especially as a courtesy to elderly guests, the cake is cut early on in the reception so that guests are free to leave when they are ready.

❋ When does the bride throw her bouquet?

This is traditionally done just before the bride and groom leave the reception. All the single females gather on the dance floor. The bride turns her back to the group and tosses her bouquet over her head to the waiting women. (Since many brides want to keep their bouquet, florists will make a separate "tossing bouquet" for this event.) Supposedly, she who catches the bouquet will be next to wed—which is why you see just as many women dodging the flying flowers as rushing to catch them!

❋ At a recent wedding, my cousin grabbed the bouquet from the woman who caught it. How do I avoid a replay at my wedding?

Sounds like she likes to be the life of the party, and during a lighthearted custom like the bouquet toss, that's not such a serious thing. Since you can't control her antics, try your best to ignore them and let her have her fun. Perhaps if she's caught one bouquet, she won't need to catch another! If you're really concerned, you can skip the bouquet toss altogether—it's not a required activity.

✳ Does my groom have to remove my garter and throw it if I throw a bouquet?

No, they're mutually exclusive activities. In some communities, the garter toss is traditional, but in all events, it should be tasteful. If you do decide to participate, wear an ornamental garter below your knee so your groom can remove it easily without fanfare. Just before the bouquet toss, the ushers gather, the groom removes your garter and tosses it over his shoulder. According to tradition, the man who catches the garter will be the next to marry. Again, there will be scurrying in both directions!

✳ Are favors a must?

Favors aren't required or necessary. While personalized, and sometimes pricey, favors are popular, but they're a wedding extra that couples can easily skip. A menu upgrade or an extra hour of dancing is a better use of your wedding dollars. Homemade favors are an alternative, but they, too, come with a price: materials and your time.

✳ **My fiancée and I met while volunteering, so we'd like to make a charity donation instead of giving wedding favors. We're concerned that not everyone may agree with the causes the charity supports. Should we provide an alternative?**

Remember, favors are always optional. Giving them in the form of a charitable donation is both appropriate and thoughtful. While some guests might object, most will understand and respect the significance of your choice. You can communicate your donation either in the ceremony program or on a small card at each table at the reception.

✳ **How do the bride and groom make their exit?**

When the party's over—usually when the music stops—it's time for the bride and groom to make their exit. The bridal party and the other guests form a corridor and the couple dashes through it to a waiting car or limo, while being showered with birdseed, rose petals, soap bubbles, or any other acceptable biodegradable material. (Yes, it's easy and important to be green! As you probably know, the traditional rice isn't recommended because it poses a danger to birds that ingest it, and it doesn't decompose easily.) Then the car, the boat, the plane, or the horse and carriage whisk the happy couple away.

CHAPTER 10

when you're a guest

❋ **Are gifts given at an engagement party?**

This depends on local custom and tradition. In many parts of the country, sending or bringing an engagement gift is considered a "must." Since gift instructions are never included on an invitation, it's fine to call the host and ask.

❋ **I just heard that my niece and her fiancé have requested "no gifts." I would really like to give her something to commemorate her engagement.**

If the couple has expressed a wish for "no gifts," the polite guest honors the request. However, if a close friend or relative really wants to honor the event, the gift should be sent to the couple or to the bride-to-be directly and not brought to

the party. Bringing a gift to the party would embarrass other guests who, correctly, did not bring a gift.

✳ How much should I spend on an engagement gift?

There's no etiquette rule that dictates a dollar amount for any gift for any occasion. Base your decision on your relationship to the bride-to-be or the couple and on your budget. An engagement gift is meant to be a token of affection and need not be elaborate or expensive. A cookbook, a special bottle of wine that might be the start of a collection, a picture frame with a picture of the couple, or a vase are all great engagement gifts.

✳ I've been asked to be a wedding sponsor. What does that mean?

In Mexico and some Latin American countries, the bride and groom find as many as fifteen couples to be sponsors, called *padrinos* and *madrinas*. These couples are responsible for a variety of the financial components of the wedding. They may pay for the bride's bouquet or the music for the reception. There is a padrino and madrina for almost all wedding categories so that the costs are divided among the couples. The groom pays for the wedding dress; the sponsors pay for almost everything else.

❊ I just joined a company and our office is having a shower for a woman I really don't know. Do I have to contribute to the gift?

No, you don't have to contribute, but it would be nice to give her a card wishing her well. Tell the person doing the collecting your circumstances and what you'd like to do instead. Contributions should never be mandatory and while a suggested amount is fine, any contribution should be welcomed.

❊ I'm just out of college, and I received an invitation to a friend's wedding. What do I do next?

Your first obligation is to check your calendar and then respond immediately, letting your hosts know if you can attend or not. Usually, there is a response card to fill in your name and a place to indicate if you are attending or not. Fill it out and return it in the enclosed envelope. Then arrange to send a gift to the bride and groom. You have this obligation whether you attend the wedding or not. The only exception is if you receive an invitation from someone you haven't even spoken to in several years, or if you receive a wedding announcement, which carries no gift obligation.

❋ The response card has an uppercase "M" with a line after it. What does it mean?

This is the place for you to write your name. The uppercase *M* stands for the first letter of a person's title, either Mr., Miss, Master, Ms., or Mrs. You fill in the remaining letters of your title and the rest of your name, like this:

Mr. and Mrs. James Finch; Ms. Aurelia Samson;
Mr. Scott Hansen.

❋ What does RSVP mean?

RSVP is the abbreviation of the French phrase *répondez, s'il vous plaît*, which means "please respond." If these letters are on any invitation, not just a wedding invitation, respond—right away, please! One of the biggest complaints I receive for any kind of party is that guests didn't respond to the invitation.

❋ There was no response card with the invitation. What's the proper way to respond?

A formal invitation is written in the third person and sounds, well, formal: Mr. and Mrs. Henry Johnson request the honour of your presence. . . ." Using your stationery, either personalized or store-bought, send back a note, also written in the third

person with all the words, including days and times, spelled out in full. Center your writing on the page so that it mirrors the style of the invitation. Here's a standard example:

Mr. and Mrs. Joseph Patterson
accept with pleasure [regret]
the kind invitation of
Mr. and Mrs. Henry Johnson
for Saturday, the twenty third of September
at half after four o'clock

The time is not included if you are sending a regret.

Replies to informal or semiformal invitations don't have to be written in the formal third-person style. Just send a short personal note or respond by telephone if that seems appropriate. In all cases, it's really considerate to respond as quickly as possible!

Dear Aunt Mary and Uncle Henry,
Joe and I are looking forward to celebrating Megan and Tom's marriage. We'll see you on September 23rd, but in the meantime, please call on us if we can help you with guests.

Love,
Jane

❋ How do I know if it's okay bring a guest to the wedding?

The names on the envelope containing the invitation are literally the people being invited, no one else. If the inner envelope says, "Ms. Tonia Ebbets," then you're the only person invited. If it says, "Ms. Tonia Ebbets and Guest," then it's you plus a guest of your choice, traditionally your significant other or a date. Don't forget to let your hosts know if you're taking them up on their offer. It's also a courtesy to supply your guest's name—it's helpful with seating charts and place cards.

❋ Is there any special guest etiquette that applies to weddings?

As for any party, you should bring your party manners, but there are a few extra things to consider at a wedding:

- Reply promptly.

- Don't bring uninvited guests or children with you.

- Send a gift.

- Be early for the ceremony.

- Turn off all pagers and cell phones. Don't take flash pictures during the ceremony.

- Be quiet and respectful during the ceremony. If you

are of a different faith, participate as your religion would permit. Stand and sit as others do, but you aren't expected to kneel or recite prayers contrary to your faith.

- At the reception, greet the bride and groom, but don't monopolize them. Move quickly through the receiving line.

- Stay away from the microphone, and keep any toasts short and sweet.

- Introduce yourself to everyone at your table. Stay at your assigned table—no switching place cards!

- If there's dancing, dance!—even if you don't think you're Fred Astaire.

- Leave the centerpiece (unless your hosts requested you take it home), leave extra party favors, and don't ask for a doggie bag!

✳ I'll be attending a friend's wedding and I just heard that my husband's ex-wife will be attending, too. We don't get along, to put it mildly. What should I do?

It's every guest's responsibility to be on their best behavior. This responsibility extends to immediate family members as well, regardless of any differences or rancor. A wedding isn't the place to wage war or provoke confrontation.

There is no reason for you to have to engage in any prolonged conversation, just greet her civilly and move on. No need to make comments about her to other guests, or complain to the hosts about her inclusion. If you don't feel that you're capable of maintaining civility throughout the proceedings, then it's best to regret the invitation without elaborating.

✳ How do I know what to wear to a wedding?

Your wedding invitation and the time of day will be your best guide to the formality or informality of the occasion. A formal invitation to an evening wedding indicates that you'll definitely dress up, and, in some parts of the country, it will mean black tie. An informal invitation to a noon wedding tells you that it will be informal or casual. If you're at the beach, you probably won't be wearing a coat and tie. If the ceremony is taking place in a house of worship, think about whether bare shoulders and

arms would be appropriate, or if head coverings are required. If you are unsure, be sure to ask the bride or groom. Whatever your attire, you should never outshine the bride or groom.

❋ Is it appropriate to wear black or white to a wedding?

Although it was long considered taboo to wear white—only the bride could wear white—or black—hey, it's not a funeral—the ban on both colors has fallen to fashion and formality. Today, it's fine to wear either color—with caution!

If you wear white, your outfit should in no way reflect, compete with, or distract attention from the bride and her attendants. A creamy white silk sheath or suit might be fine, but a full-length evening gown would not. Black is also acceptable, especially at formal evening weddings. In both cases, consider adding a bright accessory. However, if you have any doubts, wear another color.

❋ I received an invitation with a small card that says "within the ribbon." What do I do with it?

This means that a certain number of pews have been set aside—literally roped off by ribbons—for special guests and that you are to be seated in one of those pews. Bring this card with you to the ceremony and show it to the usher who will escort you to your seat.

✳ **I've received an invitation to the wedding ceremony but not to the reception. Do I send a gift?**

If you're just invited to the ceremony, then you don't need to send a gift, but you may if you wish.

✳ **Does a wedding announcement obligate me to send a gift?**

An announcement doesn't carry any gift obligation. It's nice to send a card or short note of congratulation, but it's entirely your option whether you send a gift or not.

✳ **If I'm not going to the wedding, do I still send a gift?**

Following long-standing tradition, if you receive an invitation to the wedding, you send a gift whether you attend the wedding or not. There are a couple of exceptions: You don't need to send a gift if you're a casual acquaintance or a casual business acquaintance; or if you don't know either the bride or groom well or haven't seen them in years.

✳ **I just received an invitation to my niece's wedding. When should I send her a gift?**

You may send the gift as soon as you receive the invitation. If you can't send a gift right away, make sure you do it within three months of the wedding. It's a myth that you have up to

a year to send your gift. Although better late than never, it's neither correct nor the norm.

SMOOTHING THE WAY: *Ideally, you should send the gift to the bride's or to the couple's home before the wedding. It's a courtesy, as gifts brought to a reception can easily get lost or stolen and it requires extra work on the part of your hosts to have the gifts delivered to the bride and groom. In some cultures and in a few parts of the country, it is the custom to bring gifts to the reception. If you're not sure, it's fine to call your hosts and ask where the gift should be delivered. If you aren't able to deliver the gift before the wedding, then be sure to send it within three months.*

❊ **I've been invited as a "guest of a guest" to a wedding. Do I send a gift?**

No, the person who received the invitation is responsible for sending a gift, but you aren't. However, you may certainly send one if you wish, or send a personal note or card wishing the bride and groom well.

❋ Does everyone listed on the invitation send a gift?

Usually, married couples or couples living together send one gift. If the entire Jones household has been invited, then they may send one gift from the family as a whole.

❋ A friend is marrying for the second time. Do I send her a gift? Can it be less expensive than the first?

Wedding gifts for encore couples—when the bride, groom, or both have been married before—are optional. Guests who've attended a prior wedding of the bride or groom and given a gift are under no obligation to give another. Still, if you're a close friend or relative you may want to give a present anyway, but the gift needn't be as elaborate as your first gift. New friends or friends who didn't attend a first wedding usually do send a gift, unless the word has been spread that the couple requests no gifts.

❋ Do I give a gift if I'm attending a destination wedding? Should I spend the same amount as I would for a couple getting married close to home?

Often, a bride and groom who have a destination wedding know that to a large degree "your presence is your present." Still, consider giving a gift, even if you opt for something less expensive, a handcrafted item locally made in the destination,

or something you've made yourself—often the most meaningful presents cost very little. A small yet heartfelt token is always appropriate and appreciated.

✳ **I've been invited to a belated reception for a good friend who had a destination wedding. Should I bring a gift? I'd really like to.**

Guests invited to a belated reception aren't expected to give the couple gifts, but certainly may if they wish. The gift should be presented to the couple privately or sent to their home so as to not embarrass guests who didn't bring a gift. For the same reason, gifts shouldn't be opened or displayed at the reception.

✳ **What's the correct amount to spend on a wedding gift?**

There is no "correct" amount to spend on a wedding gift. This is something you decide for yourself, based on your affection for and relationship to the couple and their families, and your budget. It's a myth that you should spend the equivalent of the per person cost for the reception.

✳ **Do I have to choose a gift from the registry?**

No, you're free to choose from the registry or not. A registry is just a list of gift suggestions based on the bride and groom's taste and needs. Some guests enjoy coming up with their own

ideas for gifts and take pleasure in selecting "just the right thing," while others are thrilled to have some guidance and a guarantee that they're choosing something the couple will love.

✻ **We'd like to personalize a gift of linens by having them monogrammed. How should they be marked?**

First, check with the couple to see how they plan to write their name(s). Today, linens are monogrammed with the couples' last name initial, hyphenated initials, or a last name initial combined with their first name initials. For a Judy Brown marrying a Thomas Nolan, the options are:

N Married, last name initial

B-N Married, hyphenated last name

B•N Married, she is keeping her maiden name

ⱼNт Married, last name initial plus first name initials

ⱼB-Nт Married, hyphenated last name plus first name initials

❋ Where are linens monogrammed?

- Towels are marked at the center of one end.

- Rectangular tablecloths are marked at the center of each long side; square cloths are marked at one corner.

- Dinner napkins are marked diagonally at one corner or centered.

- Top sheets are monogrammed in the center, above the hem, so that when the sheet is folded down the letters can be read by someone standing at the foot of the bed.

- Pillowcase monograms are centered approximately two to three inches above the hem.

❋ We're planning to give a check as a gift. How do we make it out and do we mail it or take it to the wedding?

Before the wedding, a check may be written to the bride, using her maiden name. The groom may be included as well: "Kate Lefevre [and Gino DeMarco]." After the wedding, the check

is written to the couple: "Kate and Gino DeMarco," unless the bride keeps her maiden name. You may mail the check to the bride's home before the wedding or to the couple's home after the wedding. This is usually the most secure form of delivery. In some areas and cultures it's traditional to bring gifts to the wedding. If you're not sure, it's fine to ask a family member or one of the attendants. Just be sure that your check is left in a secure location or delivered to the couple personally.

❋ **How do I know when to give money as a wedding present and when to give a gift?**

The choice and type of gift is always up to the giver. There are several things to consider when giving a gift of money: Tradition in your family, the cultural customs or circumstances of the bride and groom, and your own feelings. A gift of money can be the ideal vehicle to help the couple purchase furniture or save for a down payment on a home.

index

EMILY POST, 1872 TO 1960

Emily Post began her career as a writer at the age of thirty-one. Her romantic stories of European and American society were serialized in *Vanity Fair*, *Collier's*, *McCall's*, and other popular magazines. Many were also successfully published in book form.

Upon its publication in 1922, her book, *Etiquette*, topped the nonfiction bestseller list, and the phrase "according to Emily Post" soon entered our language as the last word on the subject of social conduct. Mrs. Post, who as a girl had been told that well-bred women should not work, was suddenly a pioneering American woman. Her numerous books, a syndicated newspaper column, and a regular network radio program made Emily Post a figure of national stature and importance.

> *"Good manners reflect something from inside—*
> *an innate sense of consideration for others*
> *and respect for self."*
>
> —Emily Post

Emily Post has defined etiquette in America since 1922. Today at The Emily Post Institute, the third and fourth generation of Emily Post's family offer etiquette advice for the twenty-first century.

The Emily Post library includes more than eighteen books on topics including everyday etiquette, wedding etiquette, business etiquette, and manners for children. The Posts author columns appearing in *The Boston Globe* (distributed by the New York Times Syndicate), *Good Housekeeping*, *Parents*, *InStyle Weddings*, *USA Weekend*, and WeddingChannel.com.

The Emily Post Institute offers a business etiquette seminar program, in which the Posts give seminars to Fortune 500 companies across the country as well as internationally. Representatives from corporations and individuals can also be trained through the Institute's Train the Trainer program where people learn to teach children's manners classes or business etiquette seminars.

The Posts are quoted in hundreds of media interviews each year, including television, newspaper, radio, and magazine features that show how etiquette touches all aspects of life.

The Posts are available for public and private appearances, seminars, workshops, media interviews, and corporate spokesperson campaigns.

Anna Post is the great-great-granddaughter of Emily Post and the author of *Emily Post's Wedding Parties*. She speaks at bridal shows, providing wedding etiquette advice and tips. As a presenter of the Institute's Business Etiquette Seminar series, she leads seminars for companies across the country. Anna also conducts corporate spokesperson campaigns.

For more information, please visit The Emily Post Institute at www.emilypost.com or call (802) 860-1814.

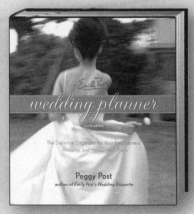